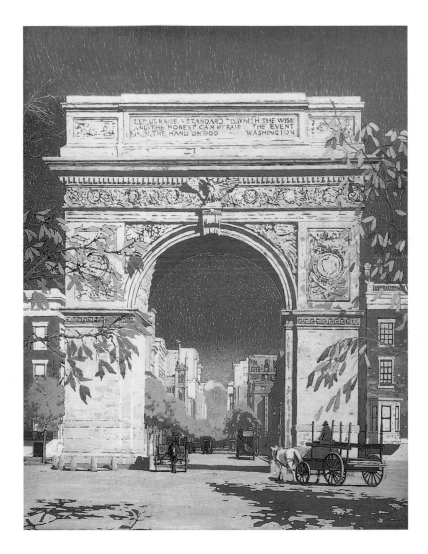

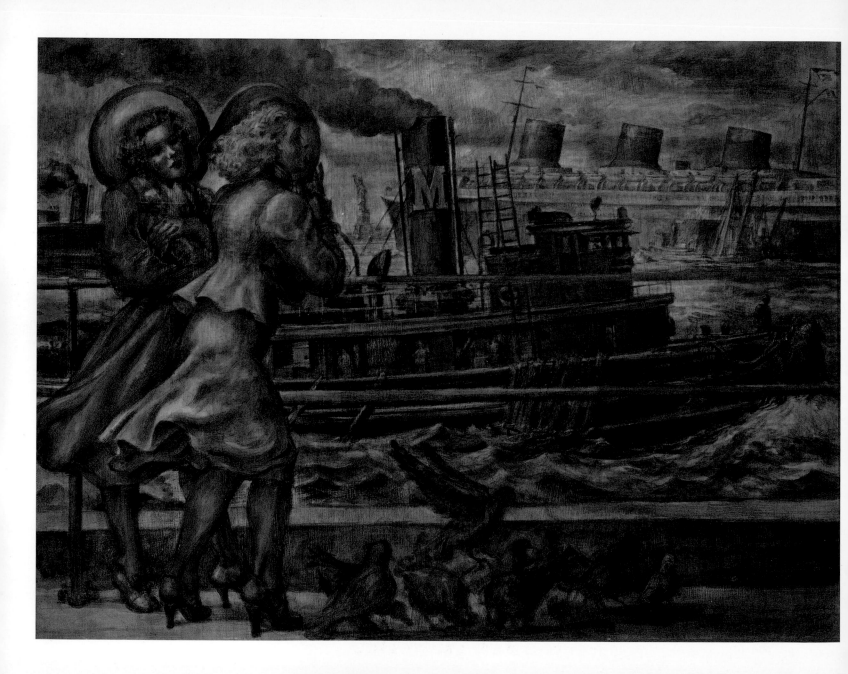

PAINTINGS OF NEW YORK 1800–1950

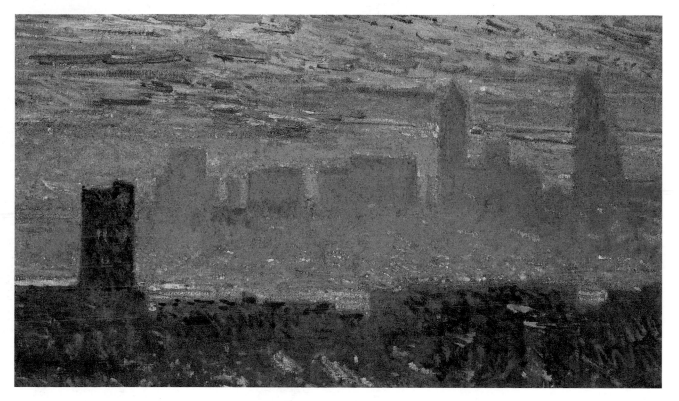

Bruce Weber

Pomegranate

SAN FRANCISCO

A CHAMELEON BOOK

Published by Pomegranate Communications, Inc.
Box 808022, Petaluma CA 94975
800 227 1428 www.pomegranate.com

Pomegranate Europe Ltd.
Unit 1, Heathcote Business Centre
Hurlbutt Road, Warwick
Warwickshire CV34 6TD, UK
(+44) 0 1926 430111

Produced by Chameleon Books, Inc.
31 Smith Road, Chesterfield MA 01012

Creative director/designer: Arnold Skolnick
Design associate: KC Scott

Library of Congress Control Number: 2005902226

Catalog number A816

Printed and bound in China
14 13 12 11 10 09 08 07 06 05 10 9 8 7 6 5 4 3 2 1

HALF TITLE
Lejaren Hiller
Washington Arch, c. 1895–1905

FRONTISPIECE
Reginald Marsh
Battery Belles, 1938

Childe Hassam
*Sunset View of the New York Skyline from Brooklyn
(The Singer Building and Bankers' Trust Building)*, 1911

ACKNOWLEDGMENTS

Many people greatly assisted with this project. Bruce Weber would personally like to thank Sarah Kate Gillespie, Jennifer Wingate, Kathryn Theisz, Olivia Ralevski, Claire Lynch, and Coleen Hopomazian for their research assistance—they also helped with other important aspects of this book. Additionally, he would like to express his gratitude to Professor William H. Gerdts for providing the use of his major library of American art, and the staffs of the Archives of American Art, the New York Public Library, the Frick Art Reference Library, the New-York Historical Society Library, and The New York Society Library. Also providing special assistance in the course of this project were Jan Seidler Ramirez; Holly Connor, Associate Curator of American Art, The Newark Museum; Lee Vedder, Henry Luce Curatorial Fellow in American Art and Curator of Nineteenth Century Painting and Sculpture, New-York Historical Society; and various members of the staff of the Museum of the City of New York, including Andrea Henderson Fahnestock, Curator of Painting and Sculpture; and Eileen Morales, Manager of Collections. Alan Axelrod superbly edited the manuscript.

PREFACE

Paintings of New York offers a fascinating visual survey of America's greatest city and of the many artists who have been devoted to depicting its rivers, streets, parks, bridges, skyscrapers, and related landmarks, as well as the day-to-day life of its people. This book includes works of art dating from approximately 1800 to 1950, focusing exclusively on the borough of Manhattan and its surrounding waters and bridges. We had considered including more recent works and even sampling images of the outer boroughs—Brooklyn, Queens, the Bronx, and Staten Island—but the number of worthy images of Manhattan was overwhelming, and, already pressed by very hard choices, we wanted to include as many as possible to convey a visual and historical sense of the New York experience. In fact, Greater New York did not come into existence until just before the close of the nineteenth century. Before then, the five boroughs were five politically separate communities. New York *was* Manhattan.

In the future, Pomegranate Communications will publish a separate volume devoted exclusively to paintings of New York from 1950 to the present.

Bruce Weber Arnold Skolnick

CONTENTS

NEW YORK IS THE PLACE WHERE ALL THE ASPIRATIONS OF THE WESTERN WORLD MEET TO FORM ONE VAST MASTER ASPIRATION, AS POWERFUL AS THE SUCTION OF A STEAM DREDGE," WROTE H. L. MENCKEN IN 1927, SUMMARIZING NEW YORK'S PASSION FOR COMMERCE AND CHANGE, ITS VITALITY FED BY THE DIVERSITY OF ITS PEOPLE AND THE CONSTANT FLUX OF ITS ENVIRONMENT.

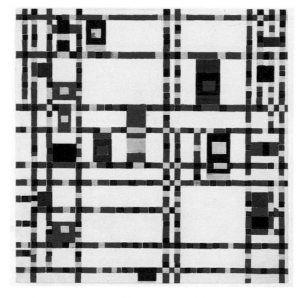

New York, the "golden door" for immigrants seeking a new life; New York, "the nation's thyroid gland." But New York, one of the greatest cities in the world, did not start out that way. This book is the story of the city's growth through the eyes of artists and writers who came to feel its allure.

The paintings presented here offer a broad view of the landmarks, people, and historical development of New York City in the nineteenth century and through the first half of the twentieth. They move from images of the city's once thriving harbor, through depictions of street life and leisure activities, and historical and commemorative events; to the growth of industry, the rise of the skyscraper, and the creation of the city's great bridges. Finally, they explore the everyday life of New Yorkers, along the way pausing to touch on an assortment of other themes, from Prohibition in the early twentieth century, when the city was under the political sway of the brown-derby-topped Alfred E. Smith—former governor and first president of Empire State, Inc. (p. 109)—to the swinging rhythms of boogie-woogie captured in the bright pulsating grid of the canvas Dutch artist Piet Mondrian painted during his self-imposed exile to America during World War II.

In the beginning, few American artists specialized in urban subjects. Between 1800 and 1875, portraiture, landscape, and rural genre painting —pictures that captured anecdotal slices of country life—dominated the American art scene. Among the rare artists devoted to depicting scenes of New York City were the genre painters James H. Cafferty (pp. 29, 30) and John George Brown (pp. 74–75), and the landscape and genre painter Nicolino Calyo (p. 67). Early-nineteenth-century artists were often moved by commercial reasons to paint topographical views of the city. Occasionally the motivation was a commission, but more often it was speculative, a painting undertaken in the hope of whetting the public appetite for such subjects. The little-known English-born artist Thomas Kelah Wharton, for example, was impressed by the view of the city he caught from Brooklyn Heights as he traveled into town from Flushing, Long Island (now Queens), where he briefly worked as a drawing instructor. He painted his only known harbor scene with the ambition of getting it engraved and marketed to the public in

PIET MONDRIAN, Broadway Boogie Woogie, 1942–43

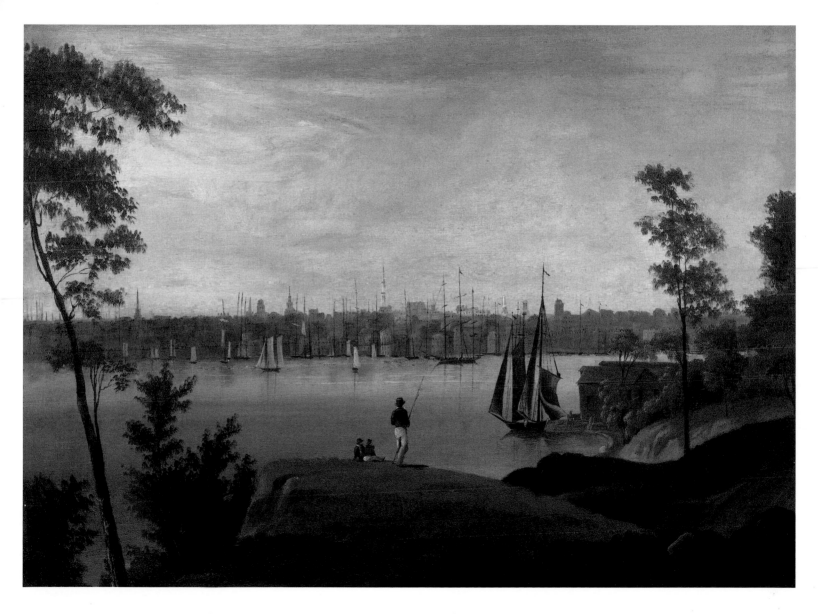

Thomas Kelah Wharton, New York from Brooklyn Heights, 1834

a big way. Even after he failed to garner the enthusiasm of James Smillie—an important early engraver of New York scenes—he remained undeterred and continued to seek an engraver. Wharton's persistence paid off, as the painting was finally engraved by Albert W. Graham and issued as a supplement to the *New York Daily Mirror* of April 12, 1834. The writer of the article that accompanied the illustration made special mention of the fact that it is a "view of New-York seldom chosen by the painter. . . . It is a view of the business side of the town; where, through the forest of shipping, a long low line of tall warehouses seems to spring from the very bosom of the waters."

The major Gloucester, Massachusetts, marine painter Fitz Hugh Lane visited New York City on two occasions in the early 1850s in an attempt to broaden his artistic base. While there, he created a small group of harbor views that investigate the teeming river traffic. Lane devoted his primary attention to describing the style and character of the various vessels, so that the New York City skyline appears almost as an afterthought in the background. As in his strongest compositions, the works are marked by careful draftsmanship, sensitive control of color values, and tonal contrast. Lane's excursions to New York were evidently successful, since a number of his harbor views were acquired by Sydney Mason, a businessman who divided his time between New York and Gloucester.

THE FLAVOR OF CITY LIFE

Visiting artists could, of course, also picture the city for completely personal or aesthetic reasons. During the early 1850s, for example, the Frenchman Hippolyte Sebron occasionally depicted the tumult of lower Broadway, near the place where he was living

FITZ HUGH LANE, New York Harbor, 1852

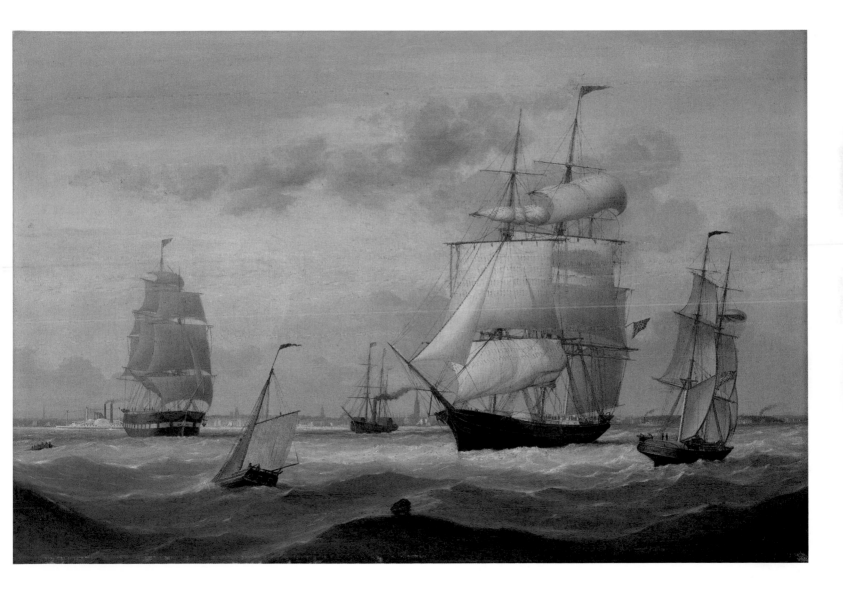

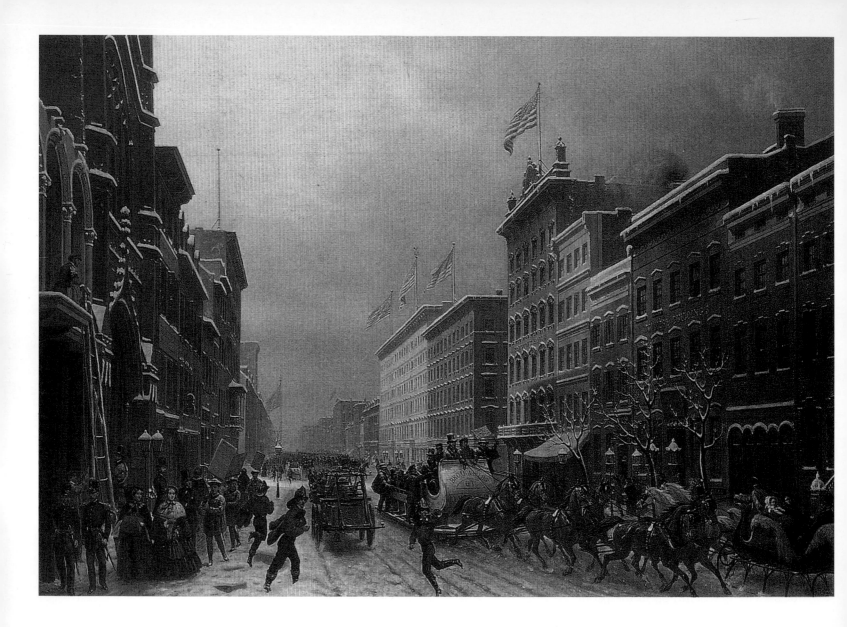

HIPPOLYTE SEBRON, Broadway at Spring Street, 1855

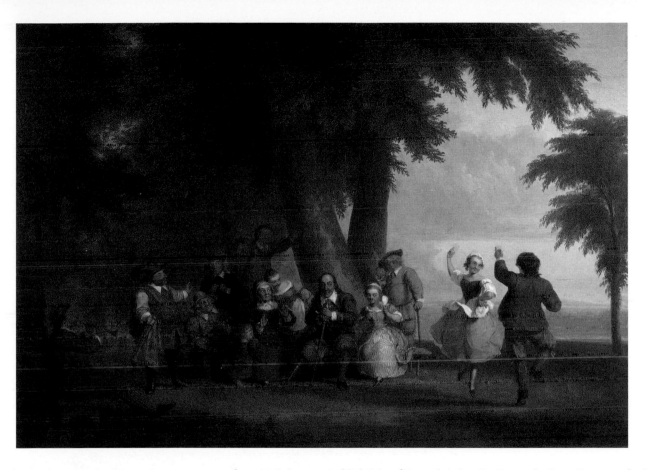

at the time. Apparently his primary reason for coming to America was to travel to Niagara Falls, where he fell in with the many foreign artists who, during the course of the nineteenth century, went there to capture the sublimity of this natural wonder—then market that sublimity to the public back home.

The place of the Dutch and the British in the early history of the city is touched on in the paintings of Johannes Adam Oertel (p. 68), and Asher B. Durand. Oertel's scene depicts the destruction of the prominent British sculptor Joseph Wilton's ambitious equestrian statue of King George III, which occurred in the aftermath of the reading of the Declaration of Independence to Washington's troops on the New York common. Durand painted *Dance on the Battery in the Presence of Peter Stuyvesant* in 1838 for Thomas Hall Faile, an art aficionado

ASHER B. DURAND, Dance on the Battery in the Presence of Peter Stuyvesant, 1838 [depicting 1809]

JOHN WILLIAM HILL, Broadway and Rector Street, c. 1850

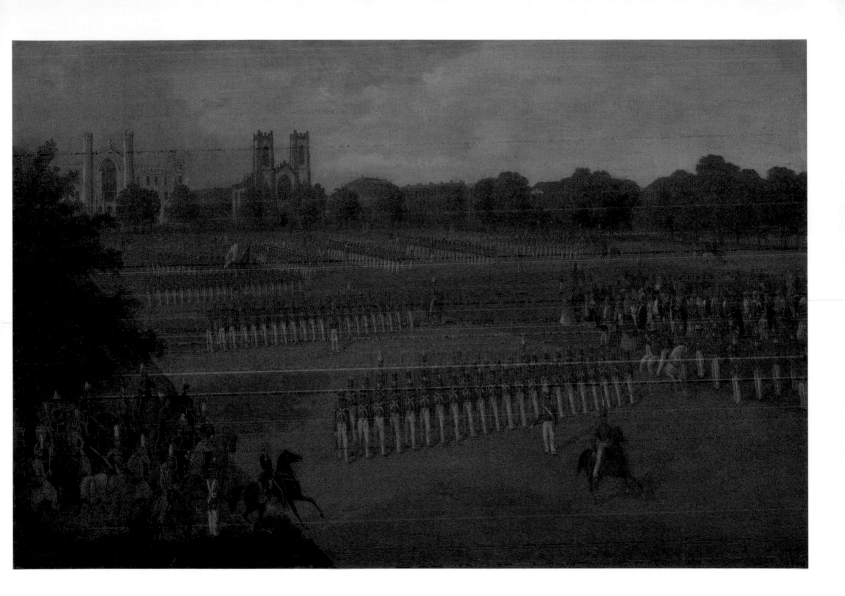

Otto Boetticher, Seventh Regiment on Review, Washington Square, New York, 1851

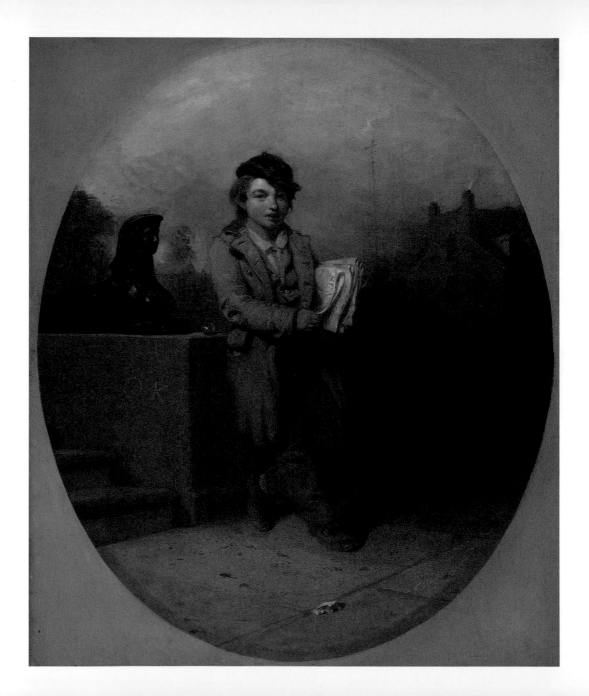

and partner in a family owned mercantile firm on Front Street. The picture is based on a passage in Washington Irving's enormously popular 1809 *Knickerbocker's History of New York*. Irving recounts how Stuyvesant, the peg-legged director general of the New Netherland colony, joined a group of burghers at the southern tip of the city to observe the autumn dance festivities. The prudish and crusty Dutchman was scandalized by the sight of a young woman's short petticoats lifted in the breeze as she whirled in a jig. Like Irving, Durand undoubtedly wanted to offer his contemporaries some of the flavor of life in old New Amsterdam. Remnants of that era had been destroyed as the new city took shape, however, so Durand relied on his own imagination to re-create the setting.[1]

MANHATTAN'S NORTHERLY MARCH
Several paintings in this book document the city's gradual movement northward as major business establishments transformed the residential character of lower Manhattan. John William Hill's *Broadway and Rector Street* of about 1850 (p. 12) pictures the area's growing commercialization. The recently erected Empire Building, which housed offices and shops at 71 and 73 Broadway, towers over the cemetery of Trinity Church across the street, where Alexander Hamilton, Robert Fulton, and other leading figures of "old New York" are buried. Otto Boetticher's *Seventh Regiment on Review, Washington Square, New York,* of 1851 (p. 13) provides a romantic and slightly fictionalized view of the Washington Square area in Greenwich Village shortly after it became one of the city's most elegant residential districts. From 1826 to 1871, the square served as a parade ground, and the artist documents the military activity

that regularly took place there, simultaneously conveying a sense of the beauty, wealth, and rise of fashionable family life on the square. Curiously, Boetticher exaggerated the military aspect of the scene at the expense of topographical accuracy: the parade ground at this time was actually crisscrossed by straight and diagonal paths and was dotted with trees. During the 1850s and 1860s, Boetticher made several paintings of military subjects, and his picture of Washington Square was probably commissioned by the National Guard's Seventh Regiment, a wealthy volunteer company.

VIEWS OF THE MOMENT
Chance observations or encounters have often inspired artists to picture the city. In 1841, Henry Inman painted his single urban genre painting, *News Boy* (p. 14), after watching a "newsie" hawking papers in front of the recently erected Astor House, designed by Isaiah Rogers in the Greek Revival style and located on the west side of Broadway between Barclay and Vesey Streets. On the eve of the building's demolition, the May 5, 1913, issue of *The New York Times* noted that the "Astor House has been a landmark through many of New York's brief generations. . . . It was contiguous to the homes of such wealth and such fashion as the bustling little city possessed. . . . It was for some years New York's best hotel." The faint scrawl "O.K.," which appears on the wall below the sphinx, refers to the presidential race of 1840, in which the wealthy and aristocratic New Yorker Martin Van Buren—known as "Old Kinderhook," or simply "O.K."—was defeated by the populist William Henry Harrison. Here Inman subtly roots for the common man.[2] Inman's painting was originally owned by the New York merchant and diarist

HENRY INMAN, NEWS BOY, 1841

George D. Strong, who in 1840 authored a magazine article in which he expressed a strongly unfavorable opinion of the city's newsboys, whom he found to be "flagrantly rude, ill dressed and a respecter of neither person nor custom nor truth."[3] Evidently, Strong held Inman's industrious, ruddy-faced newsboy in higher regard or, at least, deemed him an exception to the rule.

In December 1896, Fernand Lungren was living at the studio building at 3 Washington Square North when he witnessed the arrival of horse-drawn carriages bearing members of high society to the wedding reception of Sydney Smith and Fannie Tailer at the home of Fannie's parents, Agnes and Edward Neufville Tailer, eight doors west of his studio. A newspaper account of the wedding reported that the "young popular couple had put the neighborhood of Washington Square and Grace Church into unaccustomed animation," and noted further that the "procession of carriages through University Place to Washington Square on the way from the church was so long as to greatly astonish and excite the passers-by in that little frequented thoroughfare, and together with those that approached through Fifth Avenue put the vicinity of the memorial arch into a most un-Washington Square like flutter."[4] In the 1880s and 1890s, Lungren specialized in painting New York in oil and watercolor, and also treated his favorite subject in magazine illustrations. His genteel views of the city came before the better-known scenes of New York's leisure class painted by American Impressionist Childe Hassam, who pictured the city in a variety of guises over a period of nearly thirty years in oil, watercolor, and etching (title page, pp. 18, 19, 78).

In the fall of 1889, Hassam settled in New York after living and studying art for three years in Paris. He rented a studio on Fifth Avenue near 17th Street, and from there produced a series of paintings that focused on the streets, buildings, and people of the immediate neighborhood. *A Spring Morning* (p. 18) features a scene on West 20th Street near Sixth Avenue. The skyline is dominated by the gold dome of the Hugh O'Neill store and the crenellated steeple of the Church of the Holy Communion. Hassam's primary subjects, however, are the fashionably dressed men, women, and children strolling along the sidewalk on a bright spring day, or entering their carriage to pay a social call. Even as he captures the shimmering warmth of the air with flickering brushstrokes, Hassam also pauses to note the telling detail, such as the watch chain and boutonniere of the man approaching from the distance, or the small dog barely visible behind the stair post.

Many of Hassam's city pictures have as their subject matter horse-drawn cabs parading down a rainy avenue (p. 19). In 1916, he embarked on his famous series of flag paintings, basing his works on the grand patriotic celebrations that took place in New York City during World War I. *The Fourth of July,* 1916 (p. 78), a dazzling image of street, sky, building, and flags, is as much a tour de force of design as a celebration of patriotism. The dozens of flags create a sea of stripes that take on a remarkable quality of abstraction.

CENTRAL PARK
The desire by wealthy merchants and landowners to have a public park comparable to those in London and Paris led directly to the creation of Central Park in the late 1850s. The undeveloped area near and above the park's southern border of 59th Street was home to struggling African Americans and Irish and

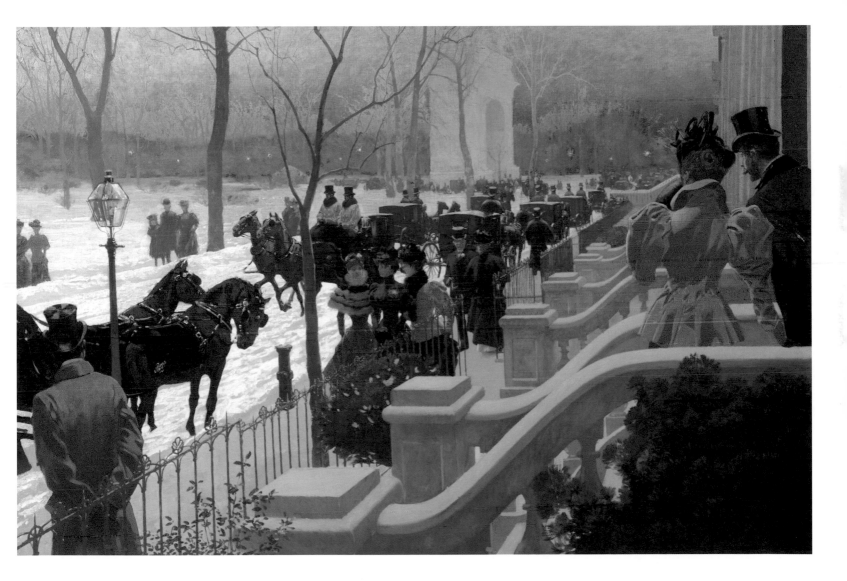

Fernand Lungren, *A Winter Wedding—Washington Square*, 1897

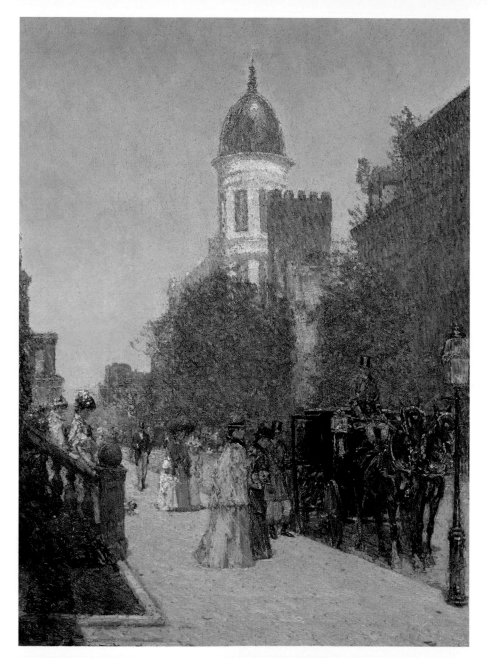

THE PORTRAIT OF A CITY . . .
is in a way like a portrait of a person—the difficulty
is to catch not only the superficial resemblance
but the inner self. The spirit, that's what counts,
and one should strive to portray the soul of the city
with the same care as the soul of a sitter.

CHILDE HASSAM
Quoted in the *New York Sun*, February 23, 1913

CHILDE HASSAM, A Spring Morning, c. 1890–91

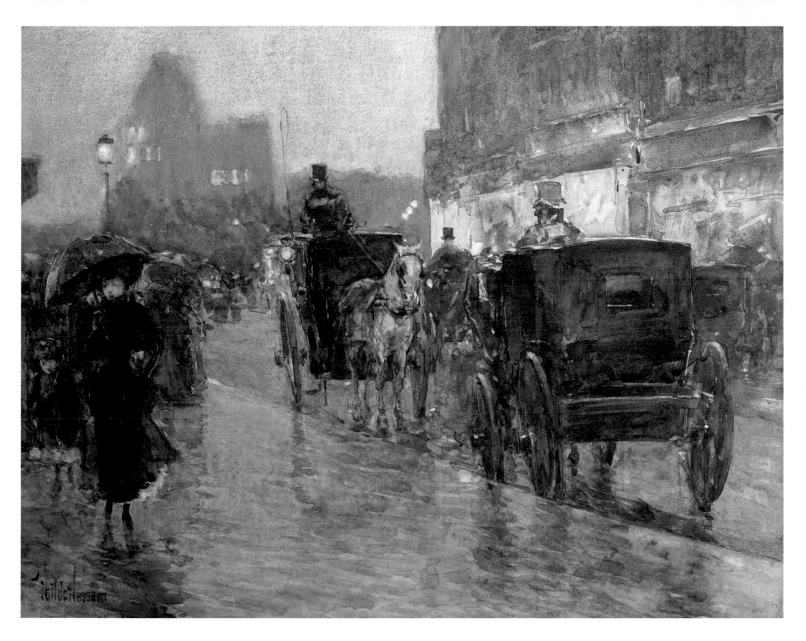

CHILDE HASSAM, Horse Drawn Coach at Evening, New York, c. 1890

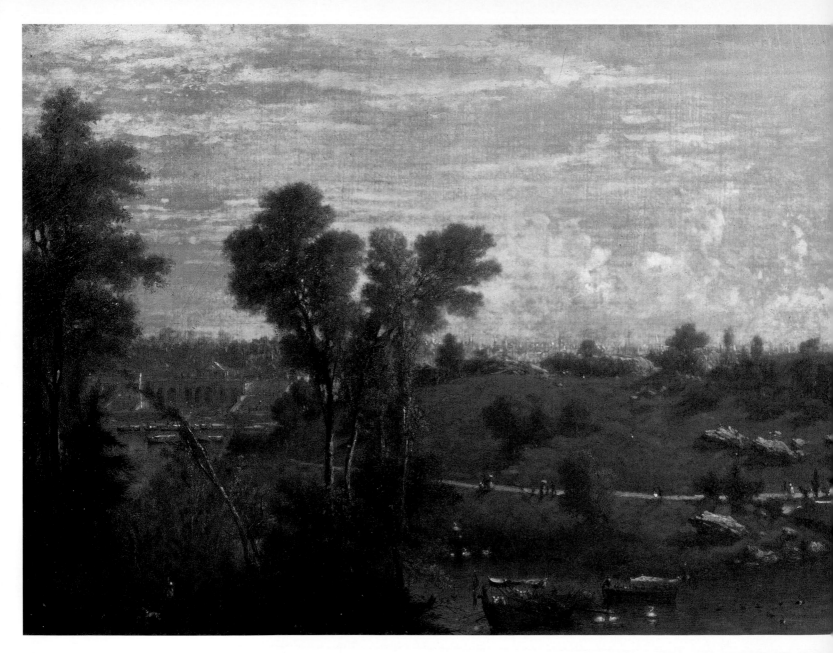

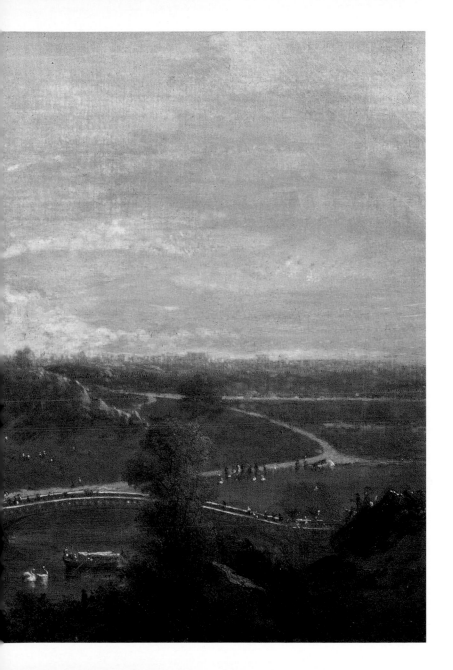

THE PRIMARY PURPOSE OF THE PARK
is to provide the best practicable means of healthful
recreation for the inhabitants of the city, of all classes.
It should present an aspect of spaciousness and tranquillity
with variety and intricacy of arrangement, thereby affording
the most agreeable contrast to the confinement, bustle,
and monotonous street-division of the city.

FREDERICK LAW OLMSTED, *Creating Central Park*

GEORGE LORING BROWN, View of Central Park, 1862

21

RALPH BLAKELOCK, Old New York: Shanties at 55th Street and 7th Avenue, c. 1870

German immigrants. The creation of the park required their dispersal and the destruction of their shanty homes, which Ralph Blakelock frequently painted. His *Old New York: Shanties at 55th Street and 7th Avenue* pictures these structures situated on a rocky outcropping (in a region that was then known as the Piggery).[5] "The Central Park—How It Looks Now," an article in *The New York Times,* March 5, 1856, reported that the area around the park featured "specimens of architecture so rickety in their disregard of rectilinear proportions, that they might make one tremble with apprehension for their inmates. . . . These little one-storied shanties are each inhabited by four or five persons, not including the pig and the goats."

Winslow Homer and John O'Brien Inman painted scenes of fashionably attired New Yorkers ice skating in Central Park (pp. 24, 25), which officially opened to the public in the winter of 1859, after crowds came to the park to skate following the flooding and freezing of the unfinished lake south of the Ramble. Skating was a favorite theme of Homer's, and he made it the subject of the first oil that he sent to the annual exhibition of the National Academy of Design. A similar scene by Homer appeared as an illustration in the *Harper's Weekly* issue of January 28, 1870. Henry Inman's son John executed his canvas shortly after the completion of the lakeside terrace in 1878; the Bethesda Fountain is visible in the background behind the skaters. In those years, the park could attract as many as 500,000 skaters a week; lamps around Bethesda Terrace even allowed skating at night.[6] Inman's New Yorkers skate by lamplight and moonlight, creating dramatic silhouettes in a landscape touched with fantasy.

Beginning in the 1880s, New York's parks became a popular subject for artistic investigation. William Merritt Chase's scintillating oils and pastels of Central Park (p. 26) and Prospect Park in Brooklyn are among the best-known American park pictures of the late nineteenth century. In these works, the artist began to come to stylistic and compositional terms with progressive artistic developments in France, and to investigate local subject matter. In the early years of the twentieth century, America's finest and most prolific painter of park subjects was Maurice Prendergast, and undoubtedly it was his watercolors of Central Park (p. 83) that served as the stimulus for Abraham Walkowitz's depictions of the park of around 1910 (p. 85). Walkowitz's park scenes reflect the influence of Henri Matisse, whose Fauvist paintings he had recently become familiar with in Paris. His exposure to the Frenchman's work led him to develop a simplified, graphic shorthand, to use pure and unmixed colors, to reduce pictorial elements to flat shapes, and to lay intense, saturated colors side by side and in balance across the entire canvas.

Many turn-of-the-century pictures of Central Park portray the leisure activities of well-to-do New Yorkers. *Music on the Mall, Central Park* (p. 27), by the Canadian-born Jay Edward Hambidge, served as an illustration for Mariana Griswold Van Rensselaer's article "Midsummer in New York," which appeared in *Century Magazine* in August 1901. It is one of a number of illustrated articles published during the late nineteenth and early twentieth centuries that focus on the lifestyles of New Yorkers. During his career as an illustrator, Hambidge specialized in depicting scenes of city life. In his painting of the park, he pictures the gazebo that served as a bandstand from 1862 to 1923. The structure stood near the head of the Mall on what is

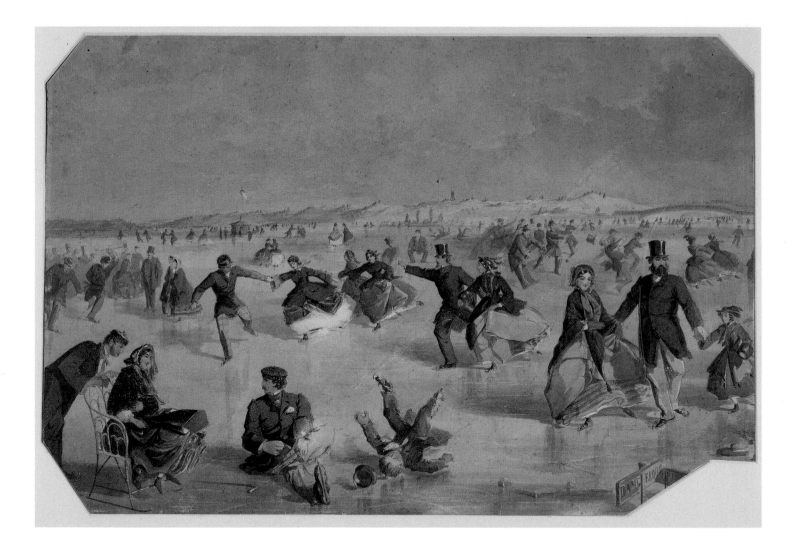

Winslow Homer, Skating in Central Park, 1860

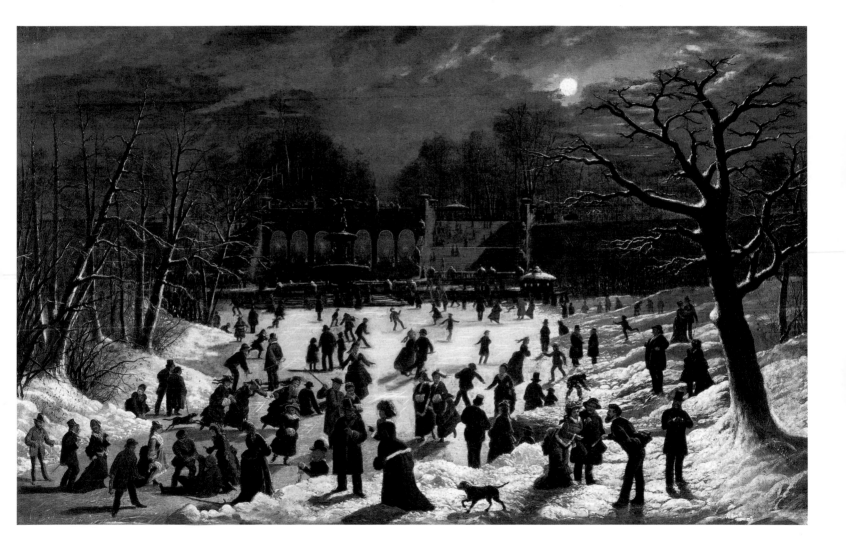

JOHN O'BRIEN INMAN, Moonlight Skating—Central Park, the Terrace and Lake, 1878

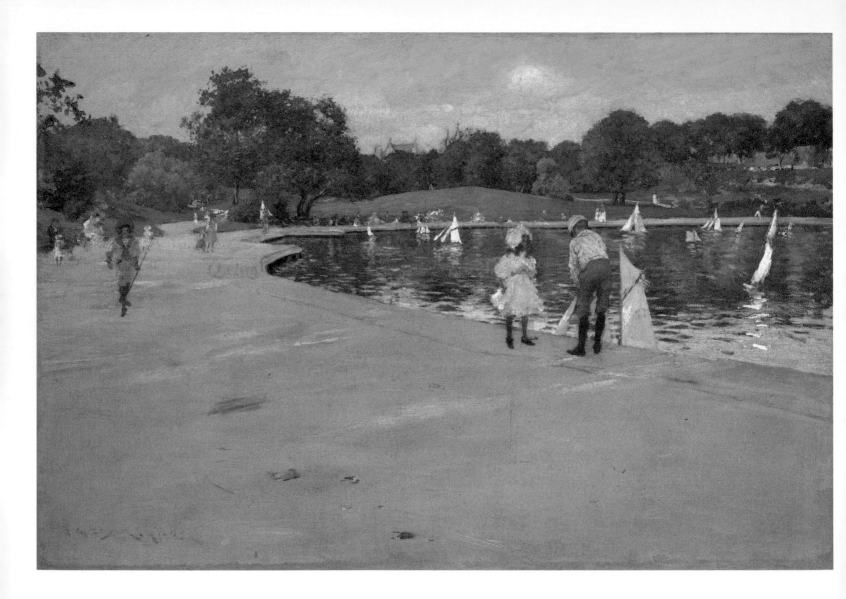

WILLIAM MERRITT CHASE, Lilliputian Boat Lake—Central Park, c. 1890

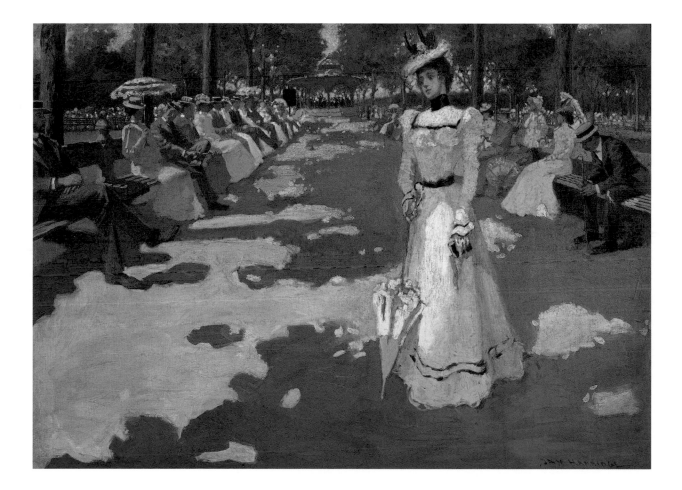

JAY EDWARD HAMBIDGE, Music on the Mall, Central Park, by August 1901

now the site of the sculpture of Ludwig van Beethoven by Henry Bearer. In Hambidge's day, the Mall was a highly fashionable gathering spot.[7]

ROUGHER REALITIES

New York artists did not confine themselves only to leisure life, but also focused on such subjects as rough-and-tumble times on Wall Street (pp. 30, 31), the sobering reality of the immigrant experience (p. 73), and the portrayal of workers trying to make ends meet through their labor on the streets and docks of the city (pp. 74–75). James Cafferty and Charles G. Rosenberg's *Wall Street, Half Past Two O'Clock, October 13, 1857* (p. 30) pictures the city's financial center on the day of the stock-market crash that plunged the country into a deep economic depression. America's financial woes began in early August 1857 with the suspension of the New York branch of the Ohio Life and Trust Company. This precipitated a commercial financial panic, as an avalanche of bad debt buried merchants, banking corporations, and manufacturing companies. The panic affected every segment of the American economy.

In *Newsboy Selling New-York Herald*, painted the year of the panic, Cafferty includes elements alluding to economic crisis. On the surface, the work resembles the artist's numerous paintings of raggedy newsies, two of whom also appear in the foreground of his painting of Wall Street. The artist viewed newsboys as symbolic of the harsh realities of urban life. In the background of *Newsboy Selling New-York Herald* is the spire of the Fourth Avenue Presbyterian Church, recently moved from its longtime location on Bleecker Street. In 1856, the church opened its new building at 280 Fourth Avenue, on the corner of East 22nd Street. This church, long active in charity, lavished such sums on the new construction that it overdrew available funds and left less for charity. Among the posters broadcasting financial distress is one advertising a lecture by Edward Everett, among the most famous American orators of the nineteenth century. In widely publicized speeches, Everett loudly blamed the panic of 1857 on the large debt the country had accrued, and spoke out for the people most gravely affected by the hard times. In February 1858, he lectured at New York's Academy of Music about the need for assisting those in distress through the creation of organized associations.[8]

Around the turn of the nineteenth century, Robert Henri and colleagues William Glackens, John Sloan, George Luks, and Everett Shinn settled in New York. They had become close friends and associates in Philadelphia, where all, except Henri, were active as artist-reporters for the *Philadelphia Press* and other local newspapers. These artists, as well as Henri's student George Bellows, formed the nucleus of what was later dubbed the Ashcan School. The term grew out of a derogatory comment that appeared in the *New York Sun* in 1916, in which the political cartoonist Art Young claimed that the only way these artists attempted to create revolutionary content was by introducing ash cans into their work.[9] Sloan personally hated the label "Ashcan School" and thought that the concept was ridiculous; in defining the aims of the group, he remarked, "We began to paint things of the city because they were interesting as life."[10]

Henri settled in New York late in August 1900, moving into a four-story brownstone at 512 East 58th Street. This address is now the upscale 14 Sutton Square, but when Henri

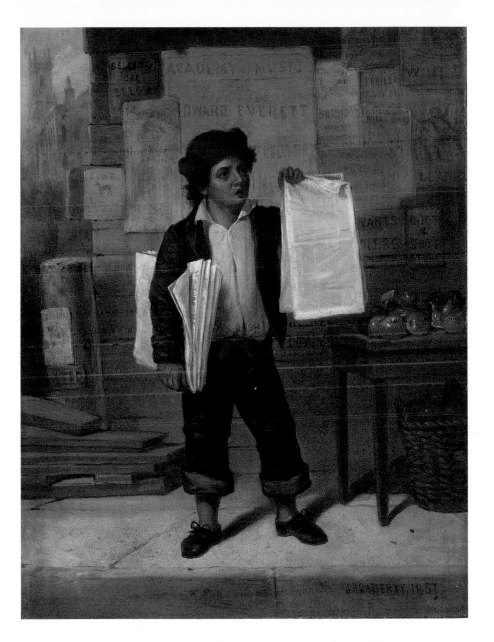

JAMES CAFFERTY, Newsboy Selling New-York Herald, 1857

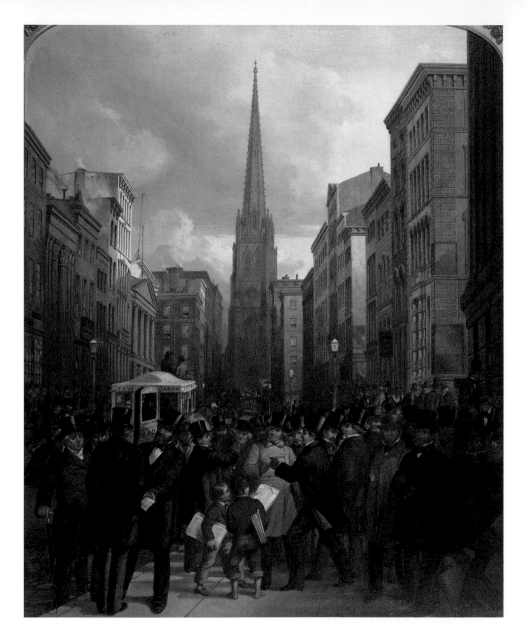

DURING THE SESSION
of the Board {Stock Exchange}, it is filled
with an excited, yelling crowd rushing about
wildly, and, to a stranger, without any apparent
aim. The men stamp, yell, shake their arms,
heads, and bodies violently, and almost trample
each other to death in the violent struggle.
Men, who in private life excite the admiration
of their friends and acquantances by the repose
and dignity of their manner, have lost the self
possession entirely, and are more like maniacs
than sensible beings.

EDWARD WINSLOW MARTIN
The Secrets of a Great City, 1868

JAMES CAFFERTY AND CHARLES G. ROSENBERG, Wall Street, Half Past Two O'Clock, October 13, 1857, 1858

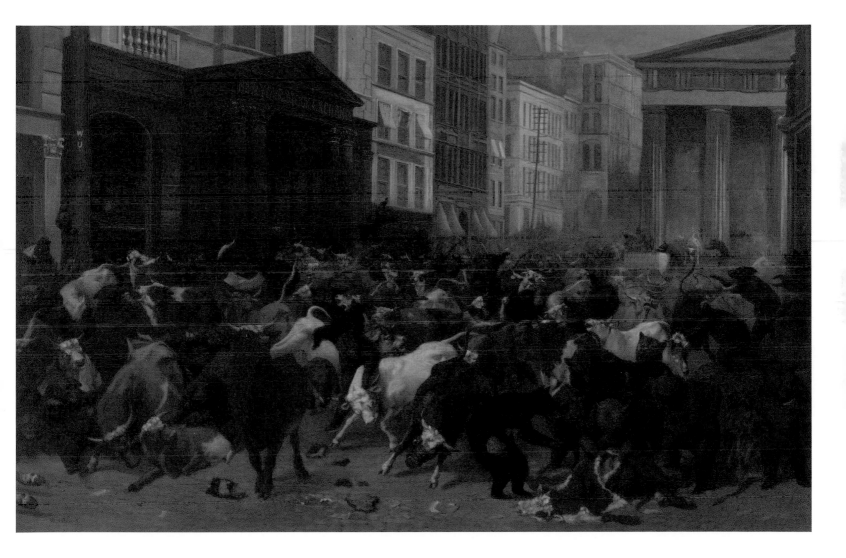

WILLIAM H. BEARD, Bulls and Bears in the Market, 1879

lived there, it was hardly a fashionable neighborhood. The artist's flat overlooked the East River, was one block from coal-loading piers, and was not far from the riverfront's many slaughterhouses as well as the city's main garbage dump. Around this time, Henri painted dark, realistic views along the river, focusing on the buildings and industrial elements he discovered there. For a brief period, he would also paint the city under a heavy snowfall, both along the river and in midtown views (p. 34). After having visited New York in December 1897, Henri remarked, "New York is so different from [Philadelphia]—one feels alive over there."[11]

William Glackens moved to New York in late 1896, and during his first years in the city, he dedicated himself to illustration. Over the course of the early years of the new century, he frequently pictured Central Park (p. 84) and Washington Square. His painting *Park on the River* of about 1902 (p. 81) features people enjoying a day of leisure in what is undoubtedly East River Park.[12] The park, which occupies a narrow strip of land along the river from East 84th to 90th Streets, was renamed Carl Schurz Park in 1910 to honor this popular German immigrant Civil War hero and statesman. In the background are a ferry, a sailing vessel, and various industries located on the westernmost tip of Long Island City, Queens, and in Greenpoint, Brooklyn. Glackens may have been inspired to picture the scene after viewing watercolors of the spot dating from 1901 by his close friend Maurice Prendergast (p. 80).

After attending Ohio State University for three years, George Bellows came to New York in September 1904 and enrolled in Henri's life class at the New York School of Art. Henri encouraged Bellows and his classmates to seek out subjects on the

ROBERT HENRI, Derricks on the North River, 1902

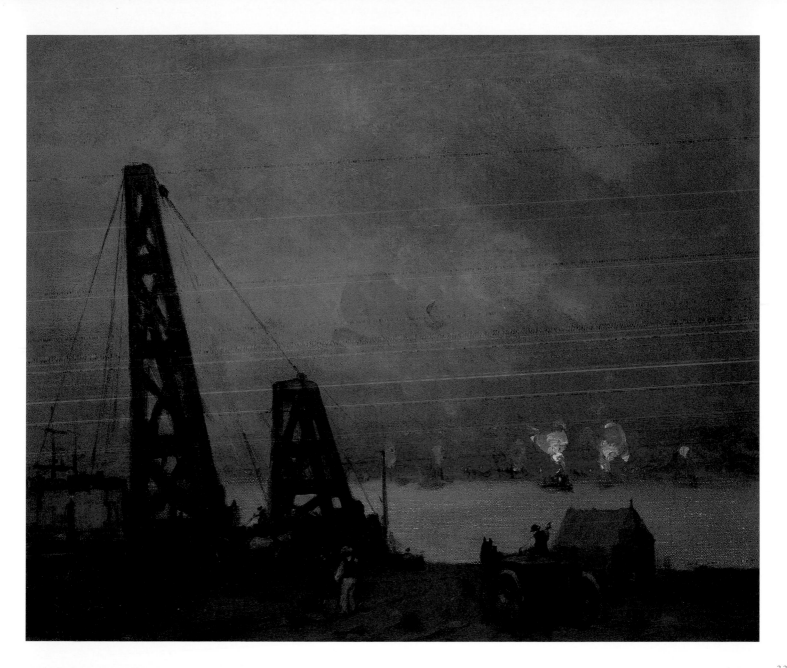

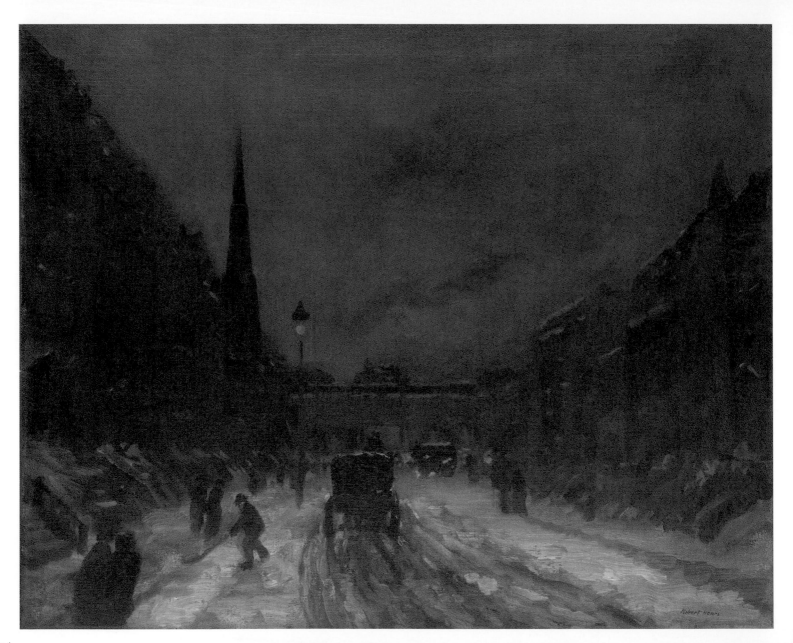

Lower East Side, and Bellows began to portray the children of the area. *Kids* (p. 87) dates from 1906 and portrays boys and girls on a downtown street, furtively horsing around, slouching, smoking, and flirting. *River Rats* (p. 86) was painted the same year and is the first of a group of Bellows paintings and prints featuring scantily clad and nude boys swimming, cavorting, and diving off docks on the East River. Bellows worked in the dark bravura manner of his teacher and put into practice what he had learned from Henri—that "There is beauty in everything if it looks beautiful to your eyes. You can find it anywhere, everywhere."[13]

Like Henri and Glackens, Bellows also painted the industrial side of New York. He produced four urban landscapes based on the construction of the Pennsylvania Railroad's New York City terminal building, Pennsylvania Station. *Excavation at Night* of 1908 (p. 36), the only nocturnal painting in the group, takes in a fraction of the site of the Pennsylvania Station excavation, from inside the northwestern edge along 33rd Street near the intersection of Ninth Avenue. The artist was fascinated by the titanic labor under way inside the pit on a winter night, the area lit only by glowing embers and otherworldly street lamps. The workmen at the bottom of the image nearly disappear into the darkness of the yawning excavation, and even the figures on the street are barely visible.

The station was the terminal for tracks leading from tunnels under the Hudson River. Before the station and tunnels were built, all railroad lines approaching New York City from the west terminated at the New Jersey waterfront, from which passengers entered Manhattan by ferry. The station portion of the project—modeled after the Gare d'Orsay in Paris—was one of

ROBERT HENRI, Street Scene with Snow (57th Street, N.Y.C.), 1902

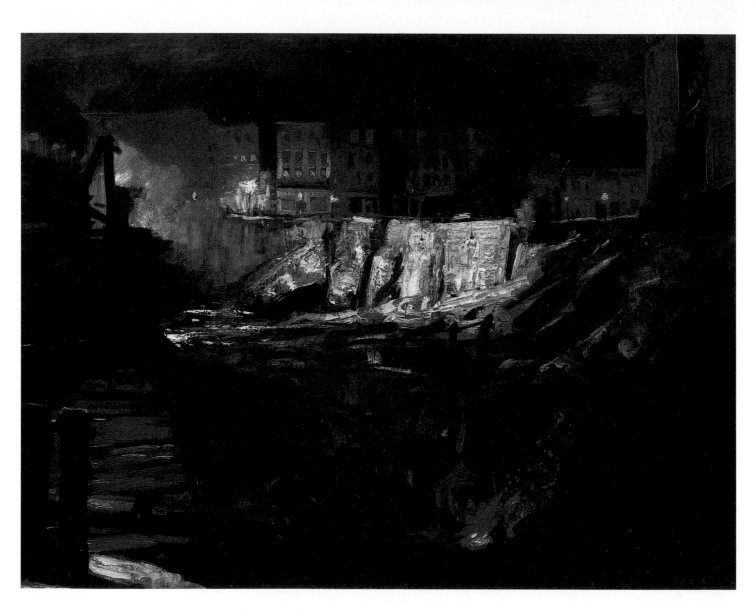

GEORGE BELLOWS, Excavation at Night, 1908

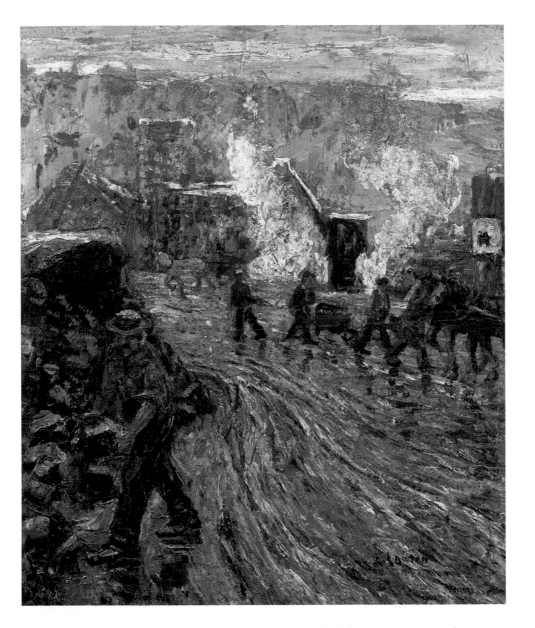

Ernest Lawson, Building the New York Subway, c. 1904–07

the most colossal and comprehensive projects for the improvement of railroad facilities ever undertaken, associated with both river and land tunnels and the widespread electrification of rail lines. Designed by McKim, Mead and White, the terminal itself occupied the long block between Seventh and Eighth Avenues in midtown Manhattan and was part of a suite of mammoth buildings, including the Pennsylvania Hotel on Seventh Avenue and the Central Post Office Building on Eighth Avenue. Tragically, Pennsylvania Station was demolished in the early 1960s to make way for the new site of Madison Square Garden, but the hotel and post office, both McKim, Mead and White buildings, remain standing.

Ernest Lawson not only depicted the excavation of Pennsylvania Station but also painted other urban industrial subjects. *Building the New York Subway* (p. 37) is one of a small group of canvases Lawson created during the first decade of the twentieth century, all of which feature men busy at physical labor at or near the tip of northern Manhattan. Lawson was closely associated with Henri and his circle, and stylistically, these works bear comparison with contemporary paintings by the group, particularly the early efforts of George Luks (p. 88). From 1898 to 1905, Lawson lived in Washington Heights, in what was still a largely unsettled area. He felt that "no artist could ask for better material."[14]

Lawson's painting depicts the early stages of construction of the uptown Broadway IRT line. The man in the foreground is probably an Italian immigrant; Italians made up the majority of the subway workforce, which consisted of both unskilled laborers and highly experienced miners, a number of whom had worked in Pennsylvania, Alaska, and South Africa.[15] Behind him, workers move materials on a handcart as well as with the help of horses. A steam crane pulls heavy rocks from the earth. Photographs documenting the construction of the subway in the collections of the New-York Historical Society and the New York City Transit Museum reveal strikingly similar scenes: workers in broad-brimmed hats, sporting handlebar mustaches, stacking large, often oily, black rocks from the dynamited roadbeds onto the pavement. During the early 1900s, streets in northern Manhattan were unpaved, and the tracks of vehicles would make long curving lines in the dirt—similar to what is portrayed here.

By 1900, a sprinkling of frame houses and tenements had been built in the northern reaches of Manhattan; fine examples appear in the background of Lawson's painting. Beyond them is a view east to the Bronx, which appears to encompass University Heights, Riverview Terrace, and Morris Heights. The identity of the buildings is difficult to determine definitively, but those depicted appear to include the Roman Catholic Orphan Asylum, the Webb Academy and Home for Shipbuilders, the Bronx campus of New York University (now home to Bronx Community College), as well as modest houses and elaborate mansions. While living uptown, Lawson began to paint *The Bridge*, located on the Harlem River at 175th Street, which remains the city's oldest bridge to date. When it was opened in 1848, High Bridge functioned as an aqueduct to carry water to Manhattan from the Croton Reservoir in Westchester. Construction of the bridge followed chronic outbreaks of cholera and yellow fever, which were attributed to the city's polluted water supplies; the wholesome Croton water was seen as a remedy.

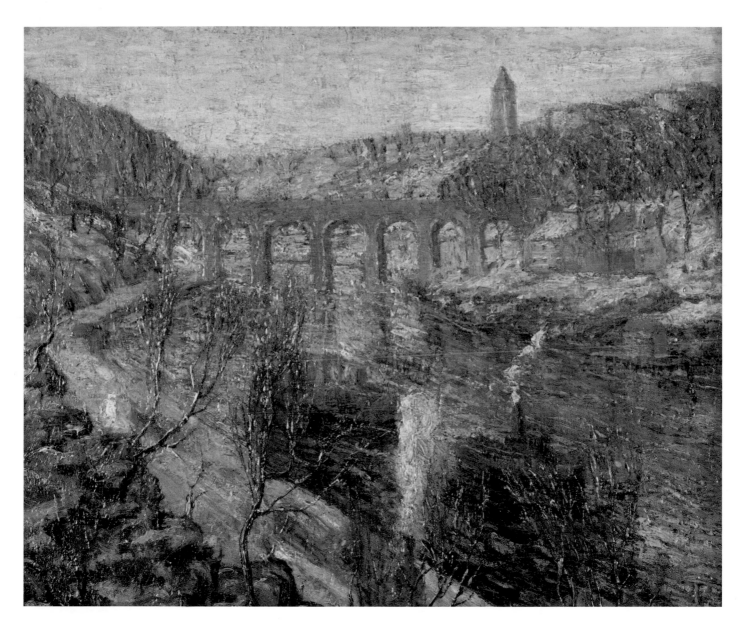

ERNEST LAWSON, The Bridge, 1912

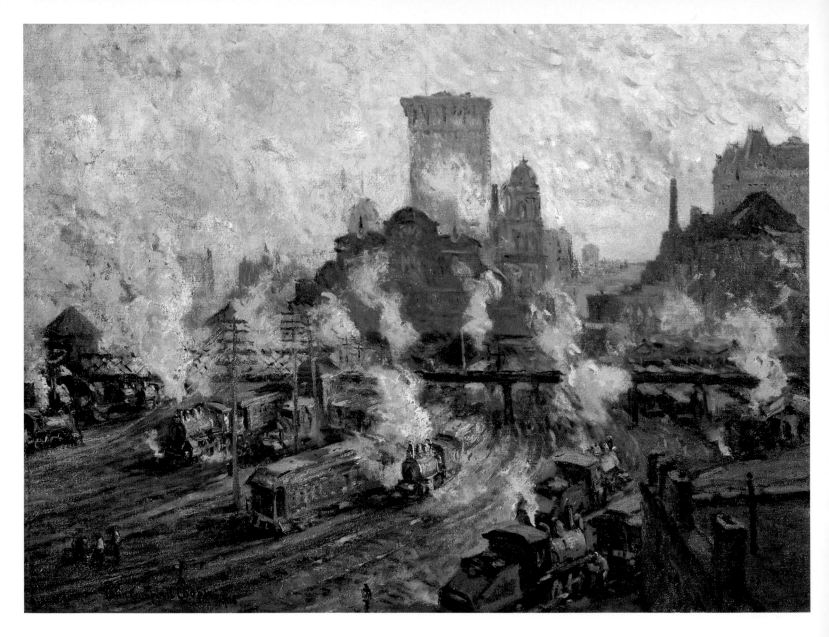

COLIN CAMPBELL COOPER, Old Grand Central Station, 1906

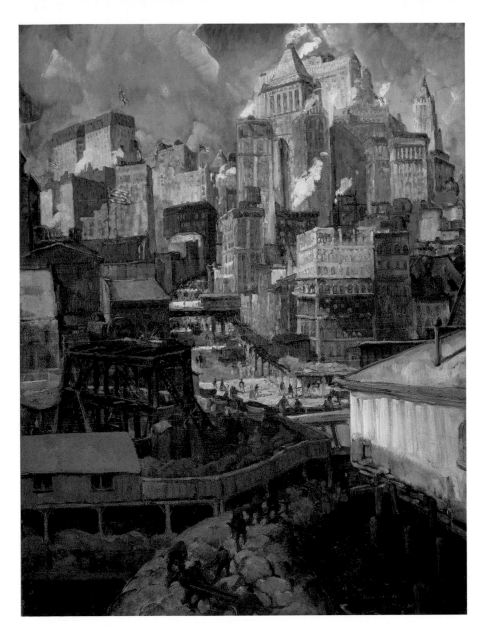

LEON KROLL, Manhattan Rhythms, c. 1915

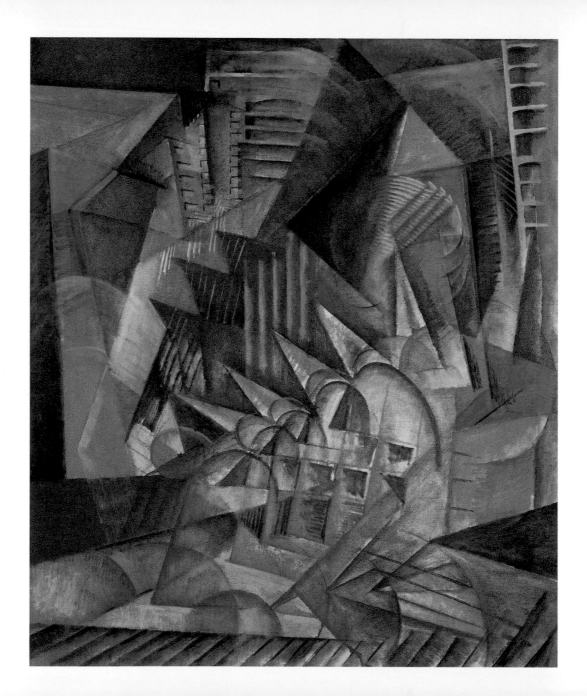

THE NEW SKYLINE

In the early twentieth century, the city's skyscrapers became the subject of canvases by a variety of Impressionists and Modernists, including Lawson (p. 44), Colin Campbell Cooper (pp. 40, 94), Leon Kroll (p. 41), John Marin, (p. 103) and Max Weber. In *Rush Hour, New York* of 1915, Weber intermingles traces of buildings, streets, and sidewalks to abstractly convey the dynamism, energy, and vitality of the city. The skyscraper, a new form of architecture, changed the way people comprehended their place in their environment and raised Manhattan's skyline from its modest nineteenth-century level.[16] Among the favorite skyscrapers was the Flatiron Building, which still stands today at the intersection of Broadway and Fifth Avenue between 22nd and 23rd Streets. The twenty-story structure was constructed in 1902 from plans by the eminent Chicago architect and urban planner Daniel H. Burnham. It remained the tallest building in New York until the completion in 1913 of the Woolworth Building on lower Broadway, which frequently inspired Marin's interest (p. 103). The Flatiron was the subject of enormous criticism and commentary by the press and public, and artists were equally ardent in their responses. The building's curious name derives from its acutely triangular plot, its footprint shaped like the old-fashioned flatiron. The future site of the Flatiron was still occupied by several small buildings when in 1892 the foresighted critic Mariana Griswold Van Rensselaer remarked: "The whole of Madison Square is picturesque to a painter . . . by day and by night, in summer and winter. Or it would be if only someone would build, on its sharp southern corner, another tall colored tower to challenge [Madison Square Garden] across the trees."[17]

MAX WEBER, Rush Hour, New York, 1915

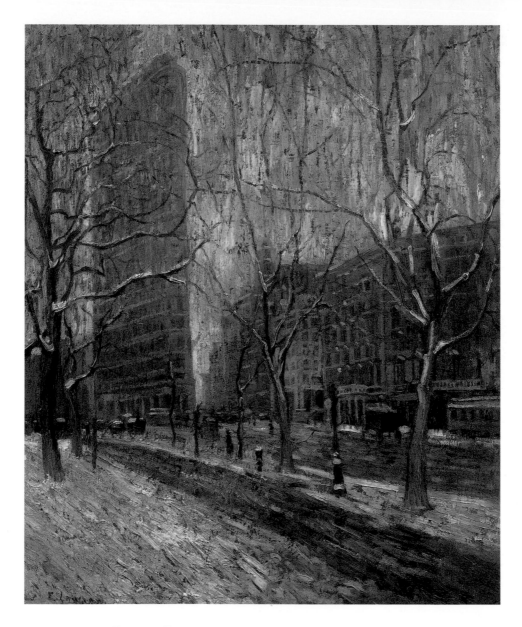

Ernest Lawson, The Flatiron Building, c. 1906–07

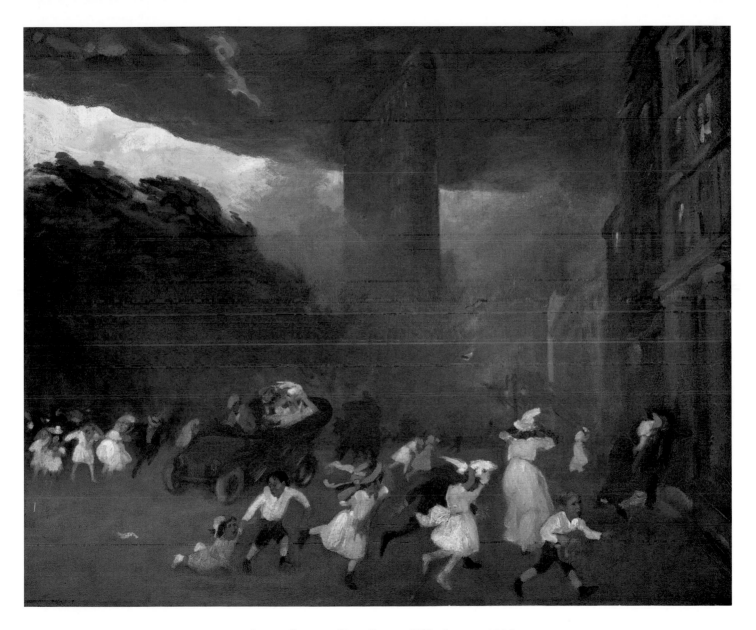

John Sloan, Dust Storm, Fifth Avenue, 1906

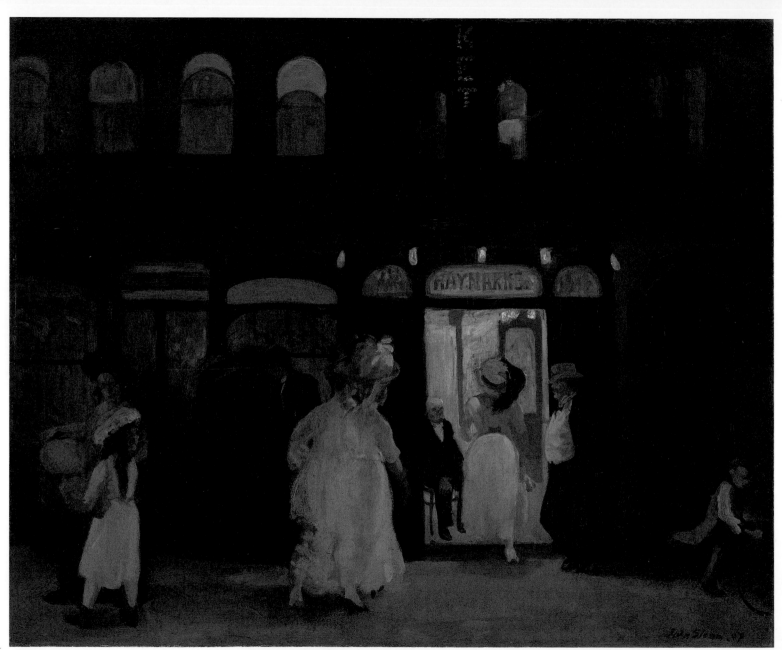

The building's unusual overall shape and curving forms allow the eye to easily take in the structure as a whole. Additionally, the Flatiron offers visual surprises when viewed from different angles; it resembles the prow of a ship when approached from the north, and a giant one-dimensional screen from the northeast or northwest. This metamorphic, chameleon-like character is part of what fascinated painters such as Lawson (p. 44) and John Marin, and photographers such as Alfred Stieglitz, Edward Steichen, and Alvin Langdon Coburn.

Shortly after its completion, the Flatiron acquired an especially notorious reputation. As reported in the New York newspapers, the wedge-shaped building created sharp downdrafts that broke large plate-glass windows, which fell and caused a boy's death, and dislodged a 200-pound piece of stone from the building, which crashed to the pavement. The accelerated, howling wind routinely frightened carriage horses into making mad dashes along Fifth Avenue, and also played havoc with women's hats and clothing. (A widespread and possibly credible legend has it that the catchphrase "twenty-three skidoo," popular throughout the early twentieth century, originated after policemen were forced to take up a special patrol at 23rd Street in front of the Flatiron Building to shoo away loitering men eager to see the wind lift women's dresses. "Hey, you," the cops would shout, "Twenty-three! Skidoo!")

In *Dust Storm, Fifth Avenue* of 1906 (p. 45), the Ashcan artist John Sloan portrayed the gust breaking over the Flatiron Building and its destructive consequences to women, children, and property. Sloan clearly recognized the comic absurdity of this controversy. Contemporary criticism and the public uproar about the wind brought the Flatiron to international attention, and the resulting publicity helped it attract interest as no skyscraper had before.

ROOFTOPS AND BRIDGES

Sloan had settled in New York in the spring of 1904 and soon found employment as a magazine and book illustrator. At this time, he also began to create paintings that embraced the life of his new neighborhood, which centered around 23rd Street and the Flatiron Building. Like other artists of his circle, Sloan rejected the conservatism of the early-twentieth-century art establishment, preferring to depict the commonplace and express the vitality of everyday experience. He focused his attention on the area known then as the Tenderloin, which spanned 23rd to 42nd Streets on the West Side: a hard-times working-class area infamous for its seedy bars, brothels, gambling dens, and street-born prostitution. *The Haymarket, Sixth Avenue* features a view outside the Haymarket dance hall on the corner of Sixth Avenue and 30th Street, which was a notorious hangout for prostitutes and denizens of the underworld.

Sunday, Women Drying Their Hair (p. 91) is one of a group of rooftop scenes Sloan painted in 1912, when he had a studio on the eleventh floor of a building at Sixth Avenue and West 4th Street, which provided him a view of neighboring roofs. Sloan remarked that this painting represented another "of the human comedies which were regularly staged for my enjoyment by the humble roof-top players of Cornelia Street."[18]

Sloan's student and friend Edward Hopper was also intrigued by unusual vantage points. From 1926 to 1928, he created several views in watercolor and oil of lower Manhattan from the Manhattan Bridge (p. 48). Hopper was fascinated by the

JOHN SLOAN, The Haymarket, Sixth Avenue, 1907

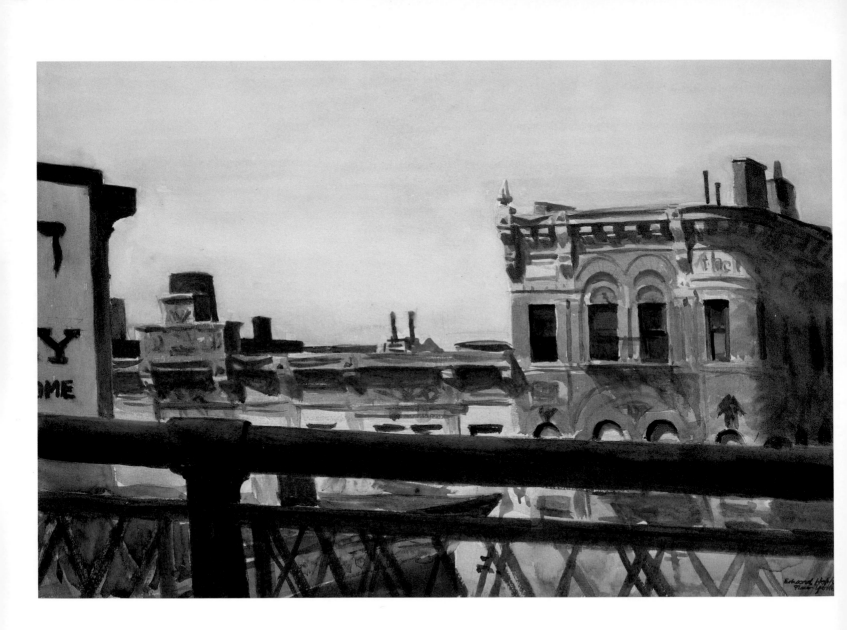

EDWARD HOPPER, Manhattan Bridge and Lily Apartments, 1926

glimpses of the buildings and the rooftops he discovered from this elevated spot. In *Chop Suey* (p. 90), he depicts the Chinese restaurant on Columbus Circle where he and his wife used to eat.[19]

New York City's bridges have been a subject of enormous artistic interest over the past century. The popular and aesthetic favorite remains the Brooklyn Bridge, which opened to great fanfare in the spring of 1883, and was the first of four major bridges to span the East River. The Italian-born Joseph Stella painted the bridge frequently over the course of more than twenty years. Indeed, this masterpiece of engineering and elegance—conceived by John Roebling and executed by his son Washington Roebling—became the signature image of this American modernist master. Stella painted *New York Interpreted: The Bridge (Brooklyn Bridge)* in 1920–22 from the viewpoint of the pedestrian promenade facing Manhattan. Visible are the blazing lights in the towering skyscrapers downtown, and the graceful pointed Gothic arches and gleaming network of the steel cables of the bridge. In 1928, Stella reflected romantically on the nights he had stood on the bridge "in the middle alone—lost—a defenseless prey to the surrounding swarming darkness—crushed by the mountainous black impenetrability of the skyscrapers—here and there lights resembling the suspended falls of astral bodies or fantastic splendors of remote rites—shaken by the underground tumult of the trains in perpetual motion, like the blood in the arteries—at times, ringing as an alarm in a tempest, the shrill sulphurous voice of the trolley wires—now and then strange moanings of appeal from tug boats, guessed more than seen, through the infernal recesses below—I felt deeply moved, as if on the threshold of a new religion or in the presence of a new DIVINITY."[20]

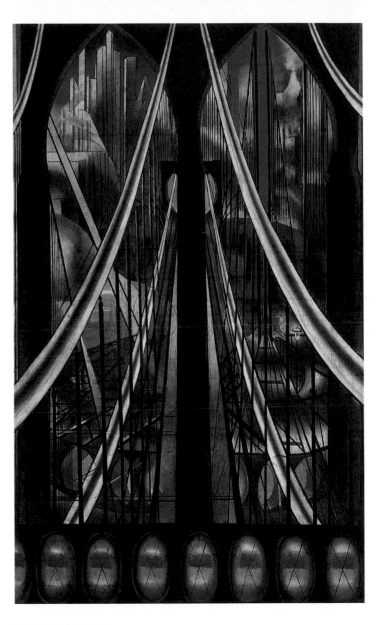

JOSEPH STELLA
New York Interpreted: The Bridge (Brooklyn Bridge), 1920–22

ALBERTUS DEL ORIENT BROWERE, The Junction of Broadway and the Bowery at Union Square in 1828, 1885

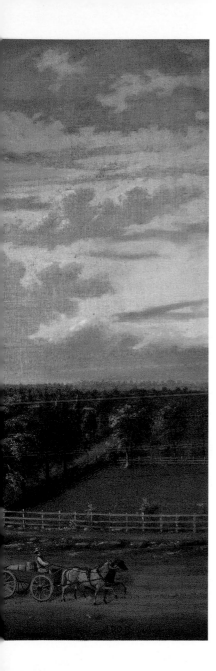

Elsie Driggs's *Queensborough Bridge* of 1927 (p. 108) was probably inspired by Stella's Brooklyn Bridge paintings. Driggs and J. Alden Weir (p. 95) chose to picture this cantilevered bridge, designed by Gustav Lindenthal and opened to the public in 1909, from the upper window of neighboring apartment buildings. The outline of the window appears at the bottom and sides of Driggs' canvas, which also features a view of the industrial buildings across the East River in Long Island City.

FROM UNION SQUARE, TO HARLEM, AND INTO THE SURREAL

Beginning in the 1920s, Kenneth Hayes Miller (p. 114), Reginald Marsh (frontispiece, p. 111), Edward Laning (p. 110), Isabel Bishop (p. 112), Raphael Soyer (p. 115), and Morris Kantor (p. 52) all had studios in the vicinity of 14th Street and Union Square. They pictured the sites and activity in this area, which was generally thought of as the poor man's Fifth Avenue. Marsh, Laning, and Bishop studied with Miller at the Art Students League, and it was he who drew them to the locale. The group of artists associated with one another socially, and so came to be known as the Fourteenth Street School. Like the Ashcan School before them, the Fourteenth Street artists chose to portray the bustling and colorful street life of working-class New York. Marsh created visually crowded scenes bursting with energy, as in his view of a movie theater facade, *Twenty Cent Movie* (p. 111). Bishop captured the look and style of shop girls—young independent women working in department stores and offices. She saw them as representing the American dream: "I want to show that these young women can move, not just physically but also in their own lives."[21]

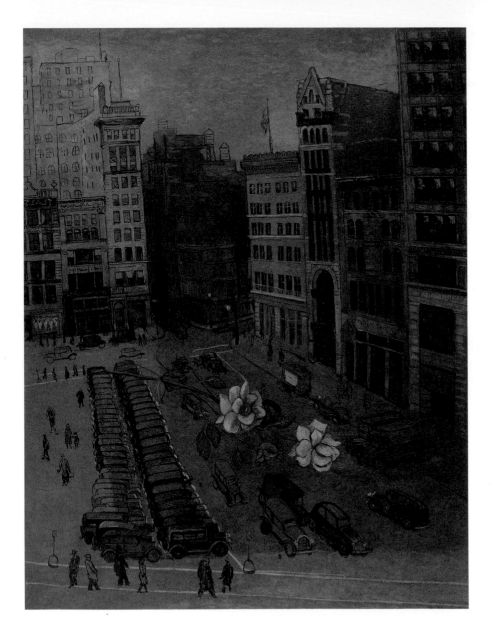

MORRIS KANTOR, Farewell to Union Square, 1931

WE CAN SAY WITHOUT DISPARAGEMENT
of the past that in that short space of time they have
gained collectively from publishers, editors, critics
and the general public more recognition than has
ever before come to Negro creative artists in an
entire working lifetime. First novels of unquestioned
distinction, first acceptances by premier journals
whose pages are the ambition of veteran craftsman,
international acclaim, the conquest for us of new
provinces of art, the development for the first time
among us of literary coteries and channels for the
contact of creative minds, and most important of all,
a spiritual quickening and racial leavening such as
no generation has yet ever felt and known.

ALAIN LOCKE, *Survey Graphic*, March 1925

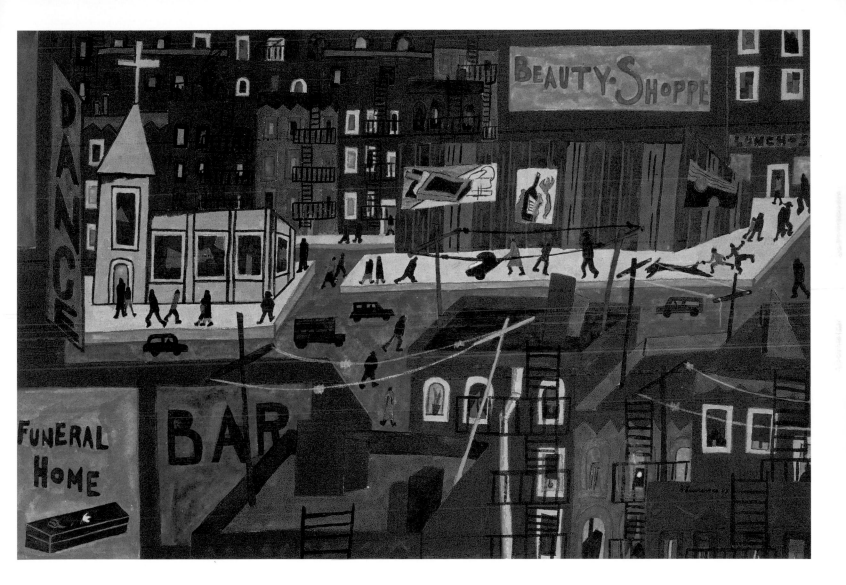

JACOB LAWRENCE, This Is Harlem, 1943

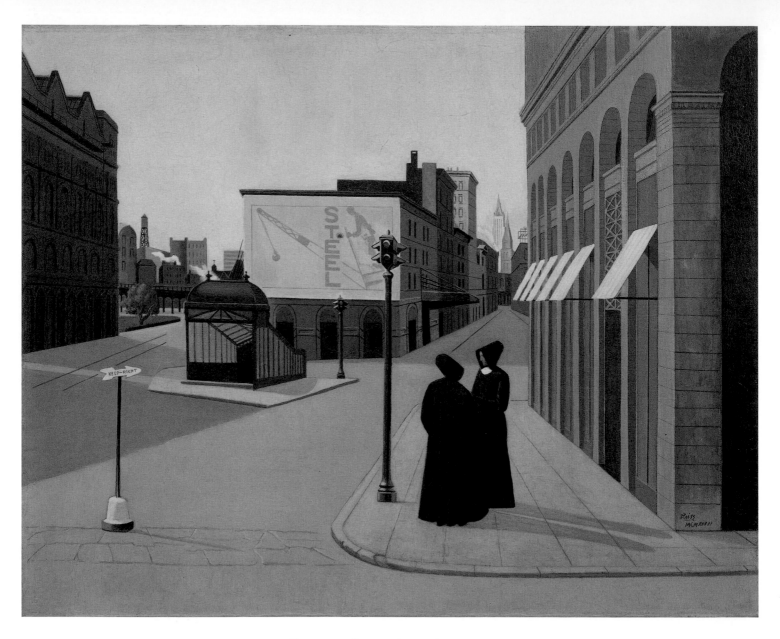

FRANCIS CRISS, *Astor Place*, 1932

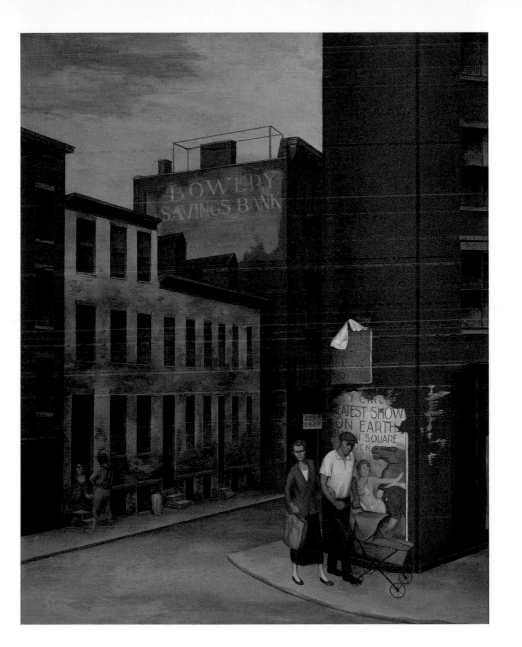

Louis Guglielmi, View in Chambers Street, 1936

Among the Fourteenth Street School's seminal works is Kantor's poignant *Farewell to Union Square* of 1931 (p. 52). The artist moved to Union Square at the end of the 1920s and frequently pictured the view from his studio window. *Farewell to Union Square* was his paean to the area. Kantor later recalled: "Every day from my studio window I used to see the two rows of cars parked in the same formation and people passing by in the same routine which impressed me to be aimless. The day I started the painting was gray and undecided. This was the last one of a series of paintings I did of the Square before I moved out to the country. This being so, I threw the roses in for good cheer."[22]

Beginning in the 1920s, Harlem became a creative hub that encompassed every facet of American culture—visual arts, literature, theater, music, and dance. The artists of the Harlem Renaissance produced works that captured some of the triumphs and struggles of the African American experience. In the early 1940s, this area inspired Jacob Lawrence to create a series of socially conscious scenes of the vibrant street life of this northern Manhattan community (p. 53). The native South Carolinian William H. Johnson also painted Harlem street scenes in around 1940 (p. 118). Following his return from Europe in 1938, he found a job teaching at the Harlem Community Arts Center. Like Lawrence, he drew on the folk art tradition and created bold, colorful, and lively renderings of the streets and people he encountered. Johnson hoped to "express in a natural way, what I feel both rhythmically and spiritually, all that has been stored up in my family of primitive tradition."[23]

The artists Francis Criss (p. 54), Louis Gugliemi (p. 55), and George Tooker created haunting and surreal images of New York. In the 1930s, Gugliemi painted scenes that convey a sense of the harsh reality of the Great Depression. His dreamlike works were critical commentaries on the social injustices of capitalism. The son of Italian immigrants, Gugliemi had grown up in Harlem and experienced his own financial difficulties in the early 1930s and applied for federal relief. Beginning in 1935, he received a regular government paycheck as a member of the easel division of the Works Progress Administration.

In the 1930s, Criss represented subway stations, skyscrapers, and factories in a strongly geometric style indebted to the early-twentieth-century paintings of the Italian artist Georgio de Chirico and the contemporary Precisionist works of Charles Sheeler (p. 107) and Georgia O'Keeffe (p. 105). His eerie painting of Astor Place (p. 54), which was located close to his apartment on East 9th Street, features two black-clad nuns, a subway kiosk, and a partial view of the Cooper Union Foundation Building, which opened in 1859.

In 1950, Tooker painted *The Subway*, a view of people making their way anxiously through the underground corridors of the city. The artist, who continues to paint in a Surrealist or Magic Realist style, related that when he painted this work, he "was thinking of the large modern city as a kind of limbo. The subway seemed a good place to represent a denial of the senses and a negation of life itself. Its being underground with great weight overhead was important."[24]

JOURNEY THROUGH A PLACE

Between 1800 and 1950, New York struggled into modernity even as its many painters kept pace—and perhaps, at times, led the way. Like the city they loved, they passed through epochs of progress and periods of reflection, culminating around midcentury in exciting, sometimes disturbing, new visions. Nevertheless, these new visions typically retained at their center the spiritual, intellectual, and even physical environment of America's ever-vibrant cultural capital.

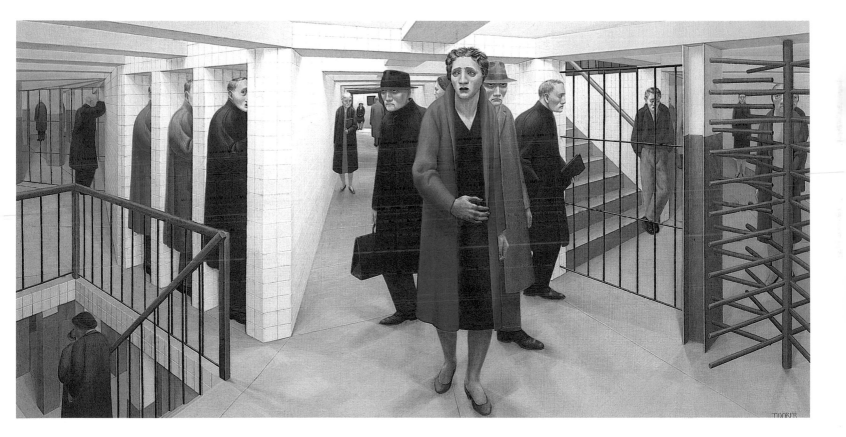

George Tooker, The Subway, 1950

ENDNOTES

1 Barbara Ball Buff and Jan Seidler Ramirez, catalog entry in *Painting the Town: Cityscapes of New York* (New York, New Haven, and London: Museum of the City of New York in association with Yale University Press, 2000), 72.

2 Elizabeth Johns, *American Genre Painting: The Politics of Everyday Life* (New Haven: Yale University Press, 1991), 186.

3 Johns, *American Genre Painting,* 185.

4 Unidentified newspaper article, Edward Neufville Tailer Scrapbook, volume for 1896, Manuscript Collection, New-York Historical Society.

5 Letter from Richard J. Coke, Curator, New-York Historical April 9, 1968, Curatorial Files, Milwaukee Art Museum.

6 Sara Cedar Miller, *Central Park: An American Masterpiece* (New York: Harry N. Abrams, Inc., in association with the Central Park Conservancy, 2003), 123.

7 Miller, *Central Park,* 28, 31.

8 "Mr. Everett's Lecture," *New York Times*, February 8, 1858, 4.

9 William Inness Homer, *Robert Henri and His Circle* (Ithaca, NY, and London: Cornell University Press, 1969), 280, ff. 18.

10 John Loughery, *John Sloan: Painter and Rebel* (New York: Henry Holt, 1995), xxi; Sloan is quoted in Homer, *Robert Henri and His Circle,* 84.

11 Henri is quoted in Homer, *Robert Henri and His Circle,* 90.

12 William H. Gerdts, *William Glackens* (New York: Abbeville Press, 1996), 61, 135. For a major study of American artists' exploration of the city in the late nineteenth and early twentieth centuries, see William H. Gerdts, *Impressionist New York* (New York: Abbeville Press, 1994).

13 Henri is quoted in Margaret C. S. Chapman, *Portraits by George Bellows* (Washington, DC: National Portrait Gallery, 1981), 16.

14 "A New Poet-Painter of the Commonplace," *Current Literature* 42 (April 1907): 407.

15 Mae M. Ngai, *Background Report of New York City Transit Museum*, "Steel Stone and Backbone" Exhibit, New York City Transit Museum, 1994, 24.

16 Percy North, *Max Weber: American Modern* (New York: The Jewish Museum, 1982), 55, and Percy North, "Max Weber: The Cubist Decade," in *Max Weber: The Cubist Decade* (Atlanta: High Museum of Art, 1991), 30.

17 Mariana Griswold Van Rensselaer, "Picturesque New York," *Century* 45 (December 1892): 170.

18 John Sloan, *Gist of Art* (New York: American Artists Group, Inc, 1939), 233.

19 Avis Berman, *Edward Hopper's New York* (San Francisco: Pomegranate, 2005), 68.

20 Stella is quoted in Barbara Haskell, *Joseph Stella* (New York: Whitney Museum of American Art, 1994), 207.

21 As quoted in Mary Sweeney Ellett, catalog entry in *Masterworks of American Art from the Munson-Williams-Proctor Institute* (New York: Harry N. Abrams, Inc., 1989), 176.

22 Artist's statement, Morris Kantor Curatorial File, The Newark Museum.

23 Johnson's remark is cited on the web site http://northbysouth.kenyon.edu/1998/art/pages/whjohnson.htm

24 Artist questionaire, George Tooker file, Whitney Museum of American Art, New York, January 30, 1951.

MANNAHATTA

I was asking for something specific and perfect for
 my city
Whereupon lo! upsprung the aboriginal name.
Now I see what there is in a name, a word, liquid, sane,
 unruly, musical, self-sufficient,
I see that the word of my city is that word from of old,
Because I see that word nested in nests of water-bays,
 superb,
Rich, hemm'd thick all around with sailships and
 steamships, an island sixteen miles long,
 solid-founded,
Numberless crowded streets, high growths of iron,
 slender, strong, light, splendid uprising toward
 clear skies, . . .
The countless masts, the white shore-steamers, the
 lighters, the ferry-boats, the black sea-steamers
 well-model'd,
The down-town streets, the jobbers' houses of
 business, the houses of business of the ship-
 merchants and money-brokers, the river-streets,
Immigrants arriving, fifteen or twenty thousand in
 a week,
The carts hauling goods, the manly race of drivers of
 horses, the brown-faced sailors, . . .
Trottoirs throng'd, vehicles, Broadway, the women,
 the shops and shows,
A million people—manners free and superb—open
 voices—hospitality—the most courageous and
 friendly young men,
City of hurried and sparkling waters! city of spires
 and masts!
City nested in bays! my city!

WALT WHITMAN, *Leaves of Grass*

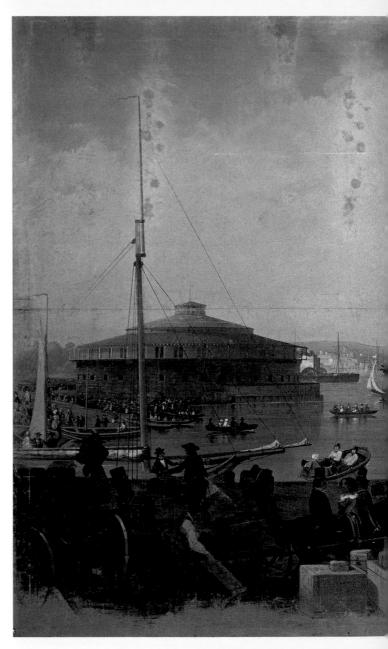

Samuel B. Waugh, The Bay and Harbor of New York, c. 1853–55

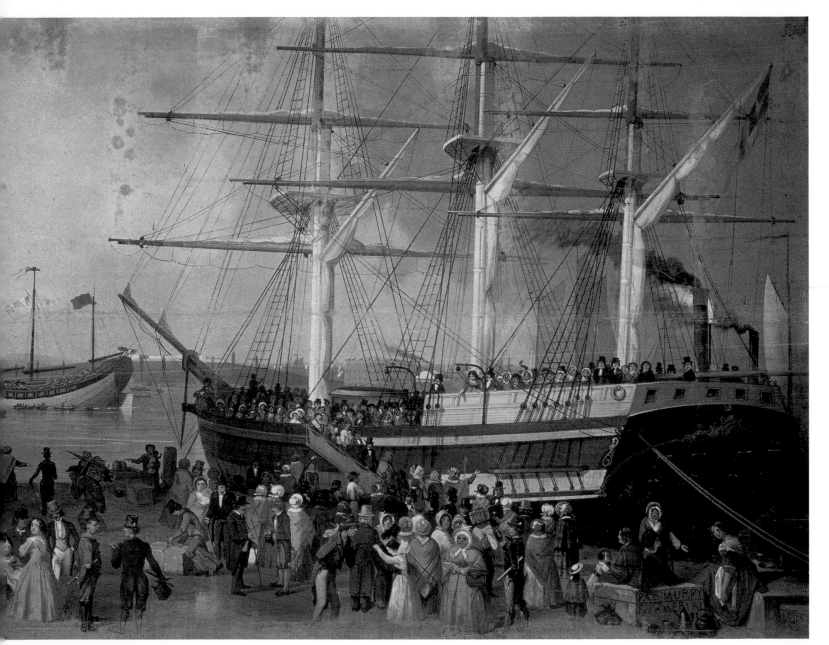

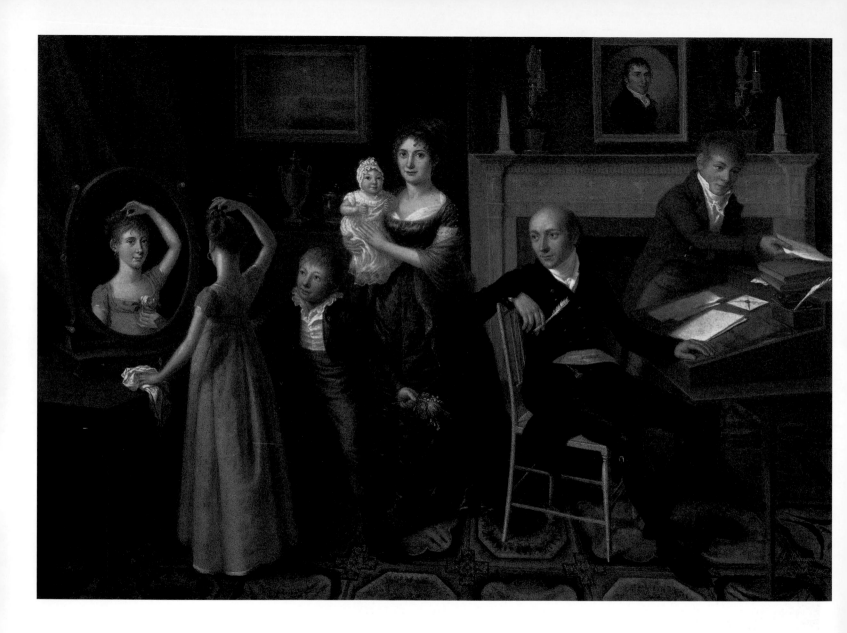

Francois Joseph Bourgoin, Family Group in New York Interior, 1807

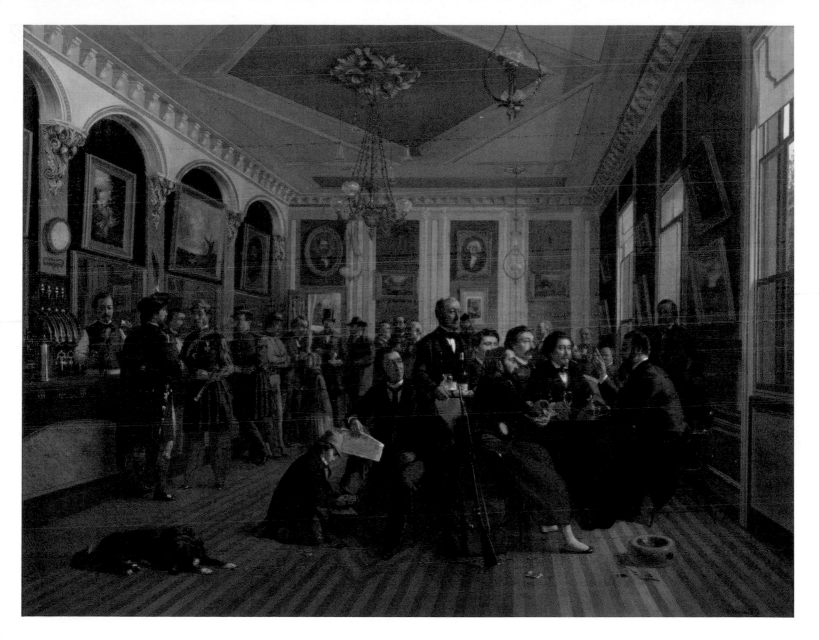

Edmund D. Hawthorn, Interior of George Hayward's Porter House, 1863

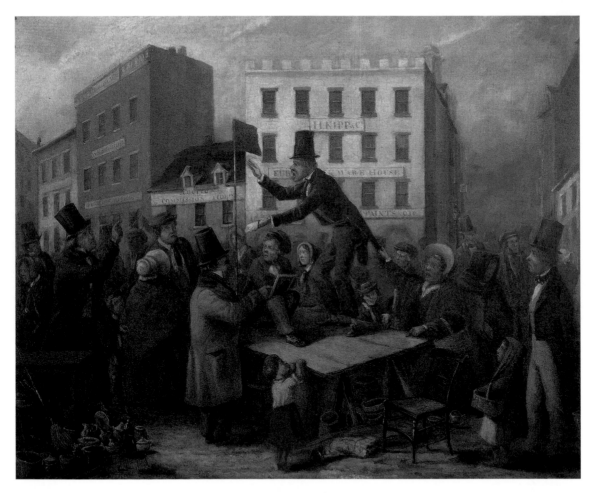

E. DIDIER, Auction in Chatham Square, 1843 [depicting 1820]

FRANCIS GUY, Tontine Coffee House, c. 1797 or possible c. 1803–1804

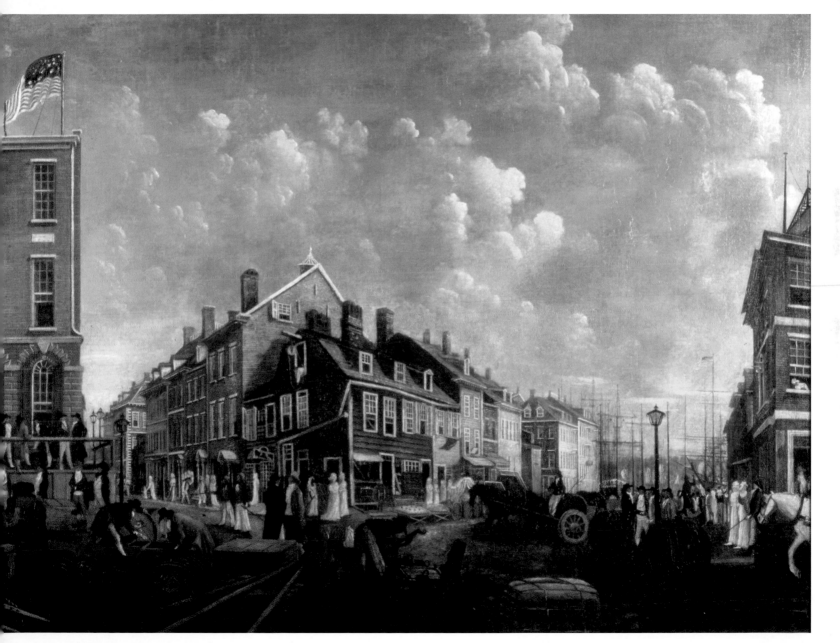

THE FIRE BROKE OUT AT NINE O'CLOCK LAST EVENING . . .

The night was intensely cold which was one cause of the unprecedented progress of the flames for the water froze in the hydrants. . . .When I arrived at the spot, the scene exceeded all description. The progress of the flames, like flashes of lightning, communicated in every direction and a few minutes sufficed to level the lofty edifices on every side. . . . The buildings covered an area of a mile square . . . filled with merchandise all of which lie in a mass of burning smoking ruins rendered the streets indistinguishable. . . . Nearly one half of the first ward is in ashes, five hundred stores are lying in a mass of ruins.

PHILIP HONE, diary entry December 17, 1835

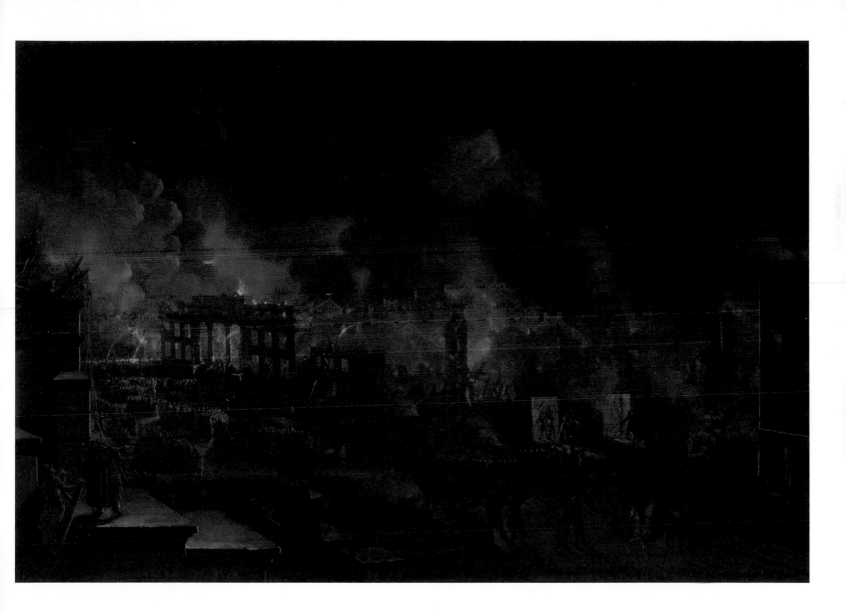

Nᴵᴄᴏʟᴵɴᴏ Cᴀʟʏᴏ, Great Fire of New York as Seen from the Bank of America, c. 1836

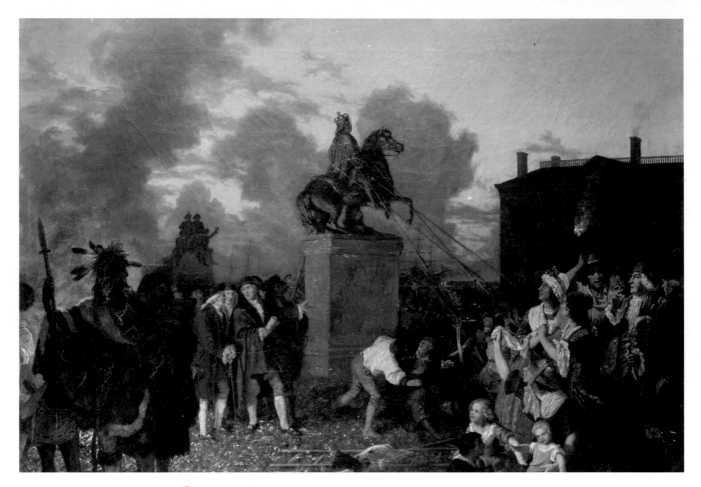

BOWLING GREEN . . . FINE PLACE FOR PASTURING COWS

. . . perquisite of the late corporation . . . formerly ornamented with a statue of George the 3rd. . . . people pulled it down in the war to make bullets . . . great pity, as it might have been given to the academy . . . it would have become a cellar as well as any other. . . . The pedestal still remains, because, there was no use in pulling *that* down, as it would cost the corporation money, and not sell for any thing.

JAMES KIRKE PAULDING, *The Stranger at Home*, 1807–08

JOHANNES ADAM OERTEL, Pulling Down the Statue of King George III, 1848

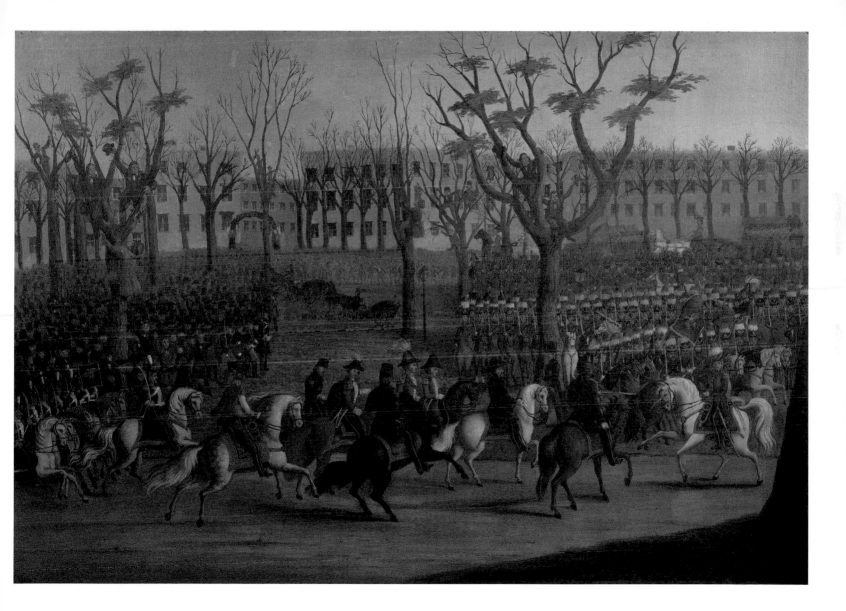

E. PERCEL, Reception of General Louis Kossuth at New York City, December 6, 1851, 1851

THERE IS NOW YOUR INSULAR CITY OF MANHATTOES,
belted round by wharves as Indian isles by coral reefs—commerce surrounds
it with her surf. Right and left, the streets take you waterward. Its extreme
down-town is the Battery, where the noble mole is washed by waves, and
cooled by breezes, which a few hours previous were out of sight of land.
Look at the crowd of water gazers there.

HERMAN MELVILLE, *Moby Dick*, 1851

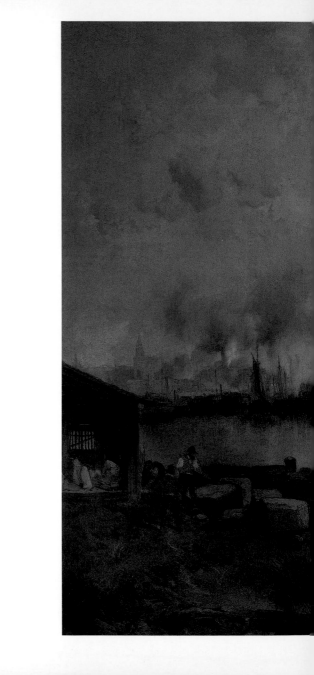

THOMAS MORAN, Lower Manhattan from Communipaw, New Jersey, 1880

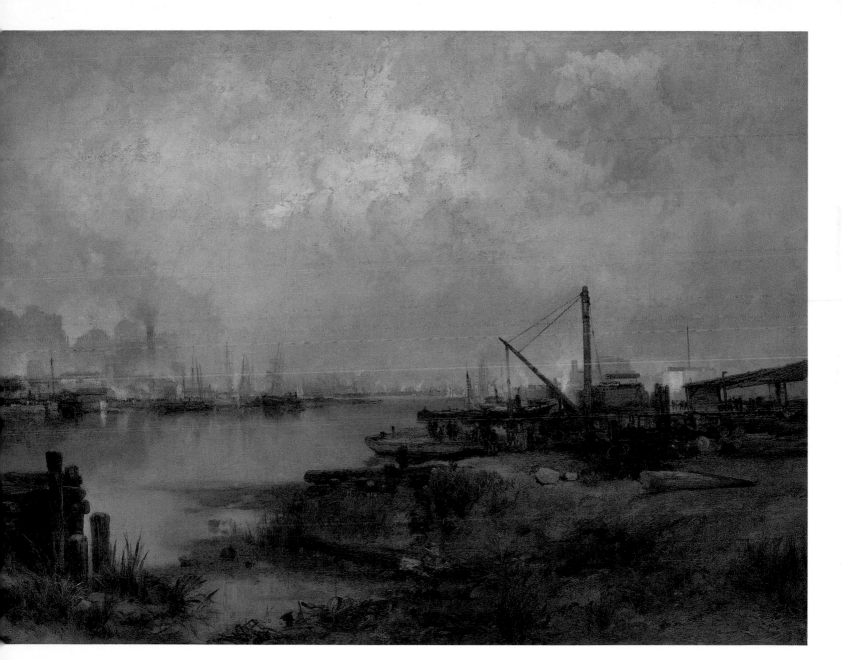

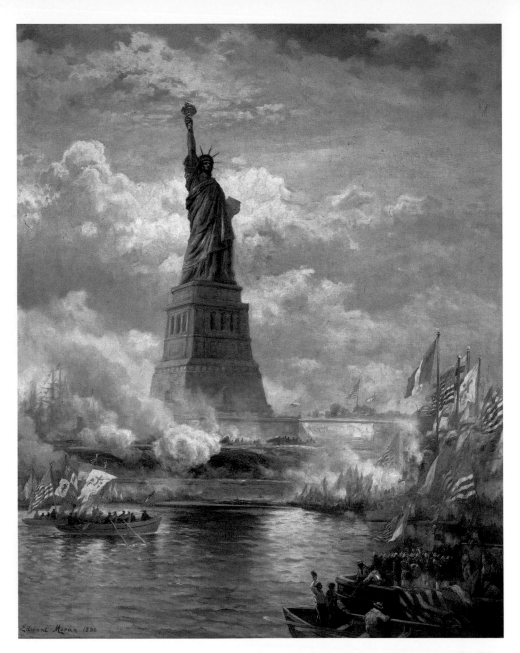

GIVE ME YOUR TIRED, YOUR POOR,
Your huddled masses yearning to breathe free,
The wretched refuse of your teeming shore,
Send these, the homeless, tempest-tost, to me,
I lift my lamp beside the golden door.

EMMA LAZARUS, "The New Colossus," inscription
for the Statue of Liberty, New York Harbor, 1886

EDWARD P. MORAN
Statue of Liberty Enlightening the World, 1886
or The Unveiling of the Statue of Liberty, 1886

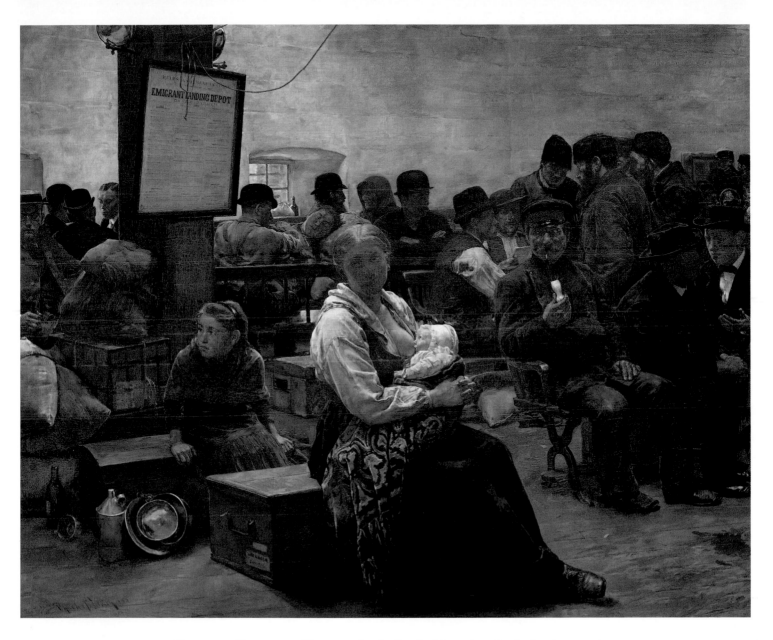

Charles Frederic Ulrich, In the Land of Promise, Castle Garden, 1884

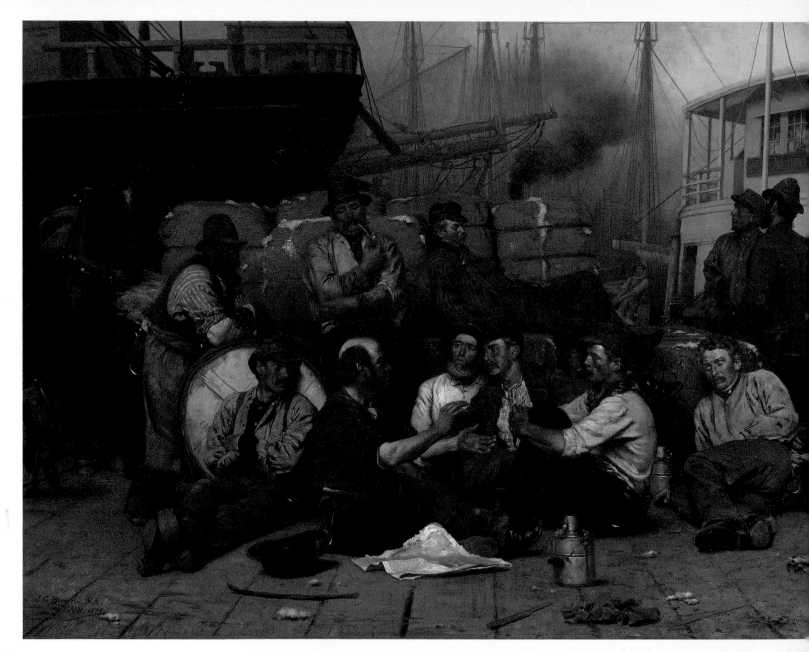

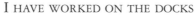

I HAVE WORKED ON THE DOCKS

with a crowd of longshoremen about me. Their usual pay is thirty cents an hour.
On one occasion, wishing to make sure of a few of them from models, I offered them
fifty cents an hour for their time. The news spread like wildfire that there was a strange
stevedore on such a wharf who was paying unprecedented rates, and in the
twinkling of an eye, there were hundreds of men before me.

JOHN GEORGE BROWN, quoted in *The Art Amateur*, November 1894

JOHN GEORGE BROWN, The Longshoremen's Noon, 1879

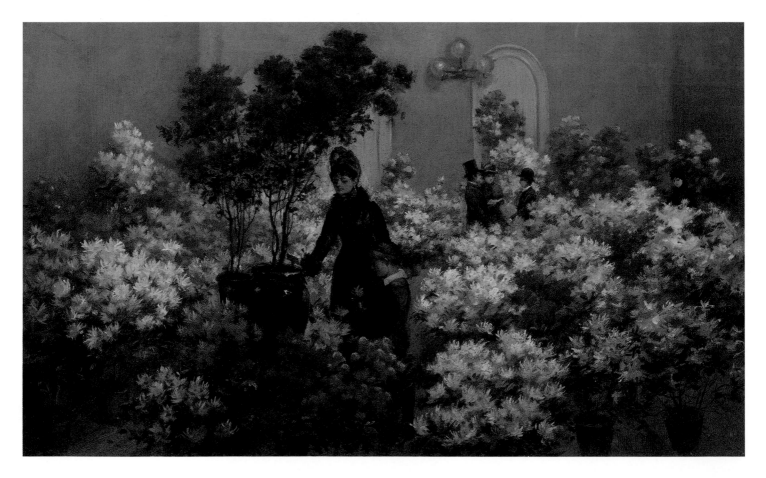

CHARLES CURRAN, Flower Market, 1885

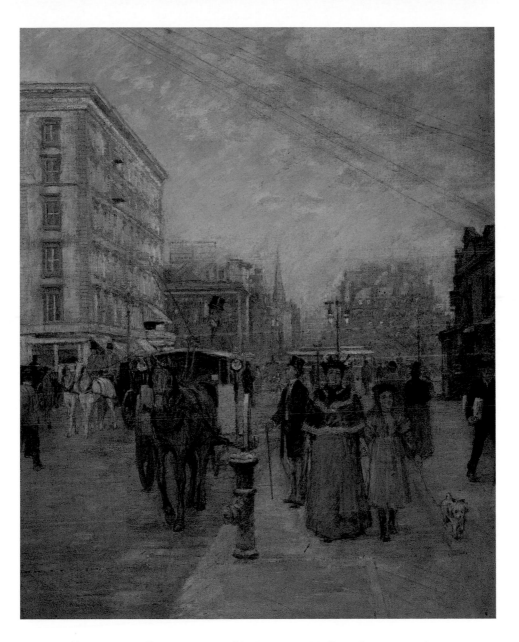

Theodore Robinson, Fifth Avenue at Madison Square, 1894–95

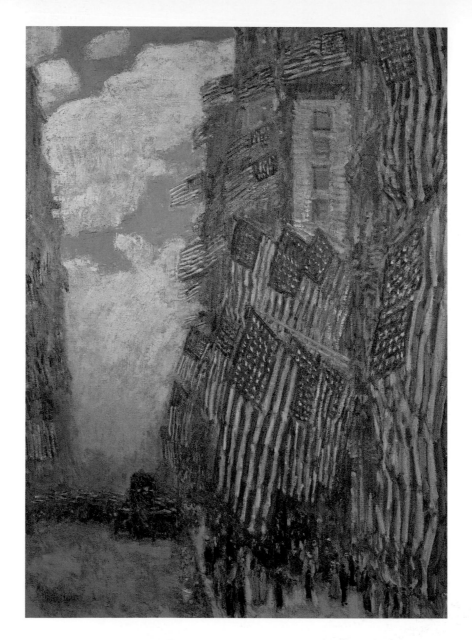

CHILDE HASSAM, The Fourth of July, 1916

WE HAVE FELT FOR SOME TIME
that the national flags of the nations associated
in the winning of the war had been neglected. . . .
The plan, as at present worked out, seems to me to
insure one of the most remarkable displays in the history
of this country. It will be a display typical
of the deep sentiment and enthusiasm on the part
of all of the people of this great city, no matter what
their origin, for the winning of the war.

We have always regarded Fifth Avenue
as a most important element in our campaign work. . . .
It is well understood that events taking place
on Fifth Avenue are reported throughout the United
States and throughout the world through the press
and through pictures.

BENJAMIN STRONG, "Glory of Fifth Avenue," *Avenue*, 1918

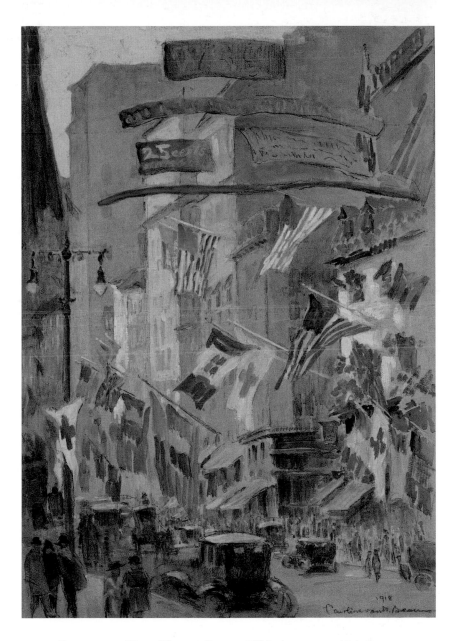

CAROLINE VAN HOOK BEAN, Fifth Avenue at 48th St., 1918

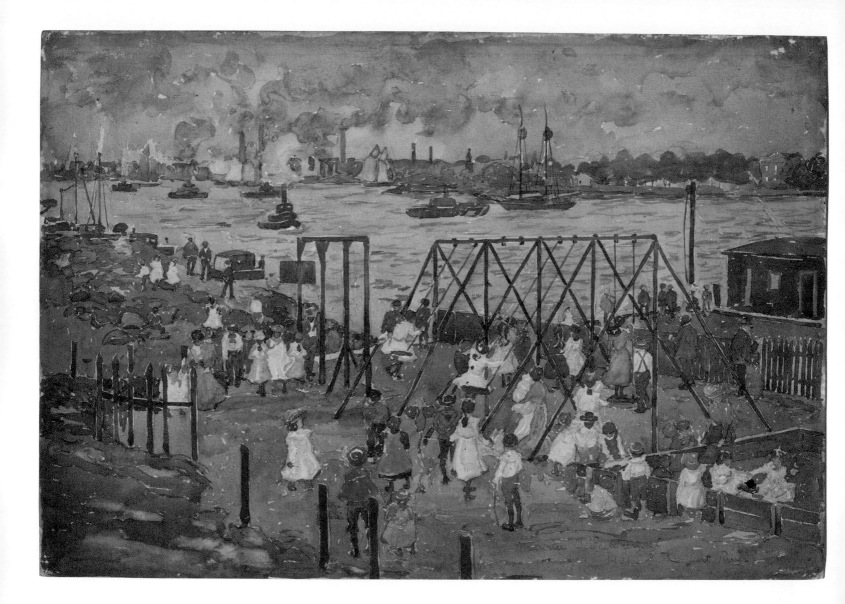

Maurice Prendergast, The East River, 1901

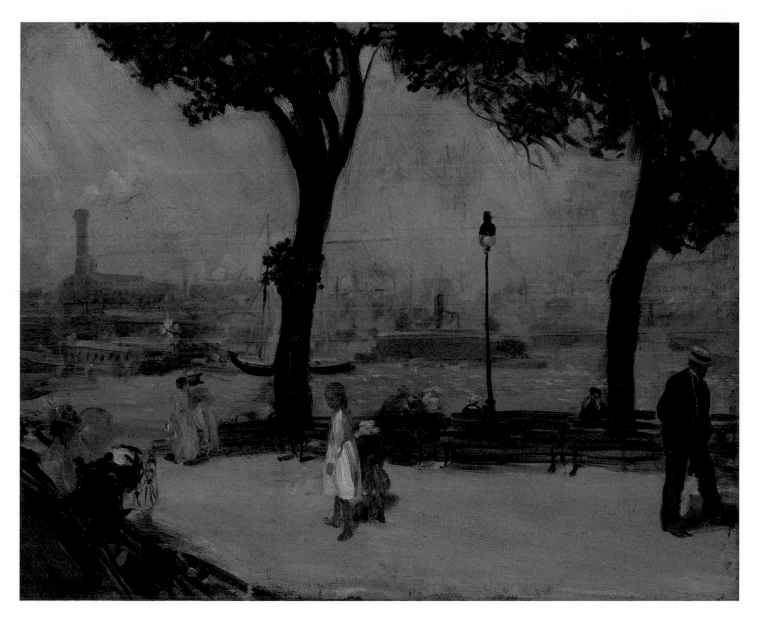

William Glackens, Park on the River, c. 1902

TEN THOUSAND VEHICLES CAREERING THROUGH THE PARK
this perfect afternoon. Such a show! And I have seen all—watched it narrowly, and at my leisure.
Private barouches, cabs, and coupes, some fine horseflesh—lapdogs, footmen, fashions, foreigners,
cockades on hats, crests on panels—the full oceanic tide of New York's wealth and "gentility." It was
an impressive, rich, interminable circus on a grand scale, full of action and color in the beauty of the
day, under the clear sun and moderate breeze.

WALT WHITMAN, *Specimen Days*, 1882

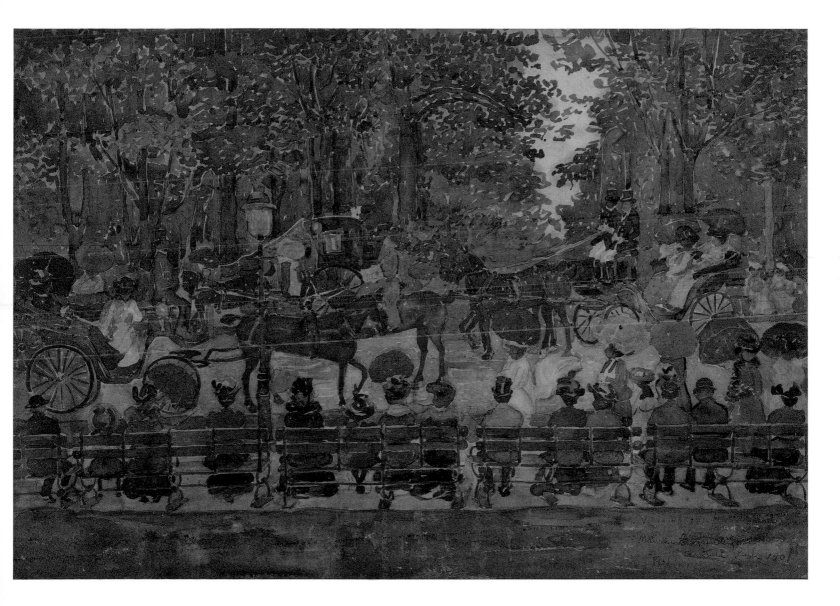

Maurice Prendergast, *Central Park*, 1901

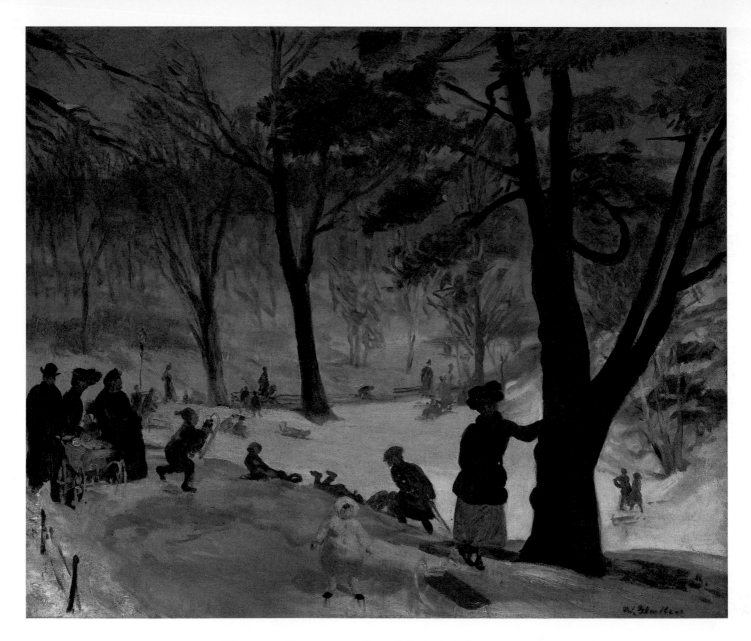

WILLIAM GLACKENS, Central Park, in Winter, 1905

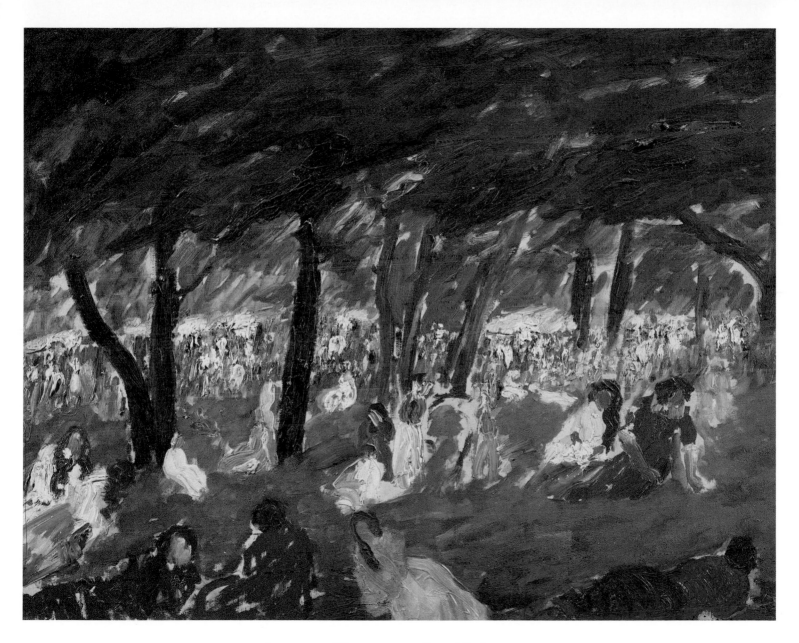

ABRAHAM WALKOWITZ, *Central Park*, 1907–09

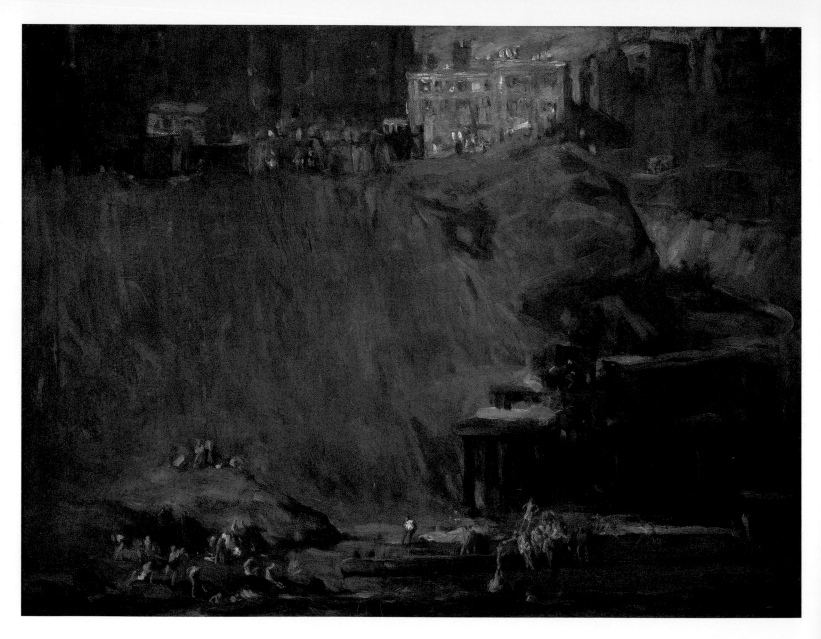

GEORGE BELLOWS, *River Rats*, 1906

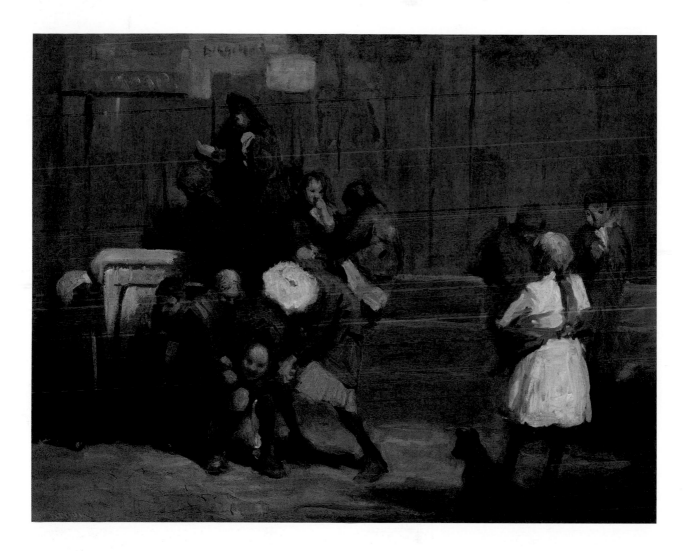

George Bellows, *Kids*, 1906

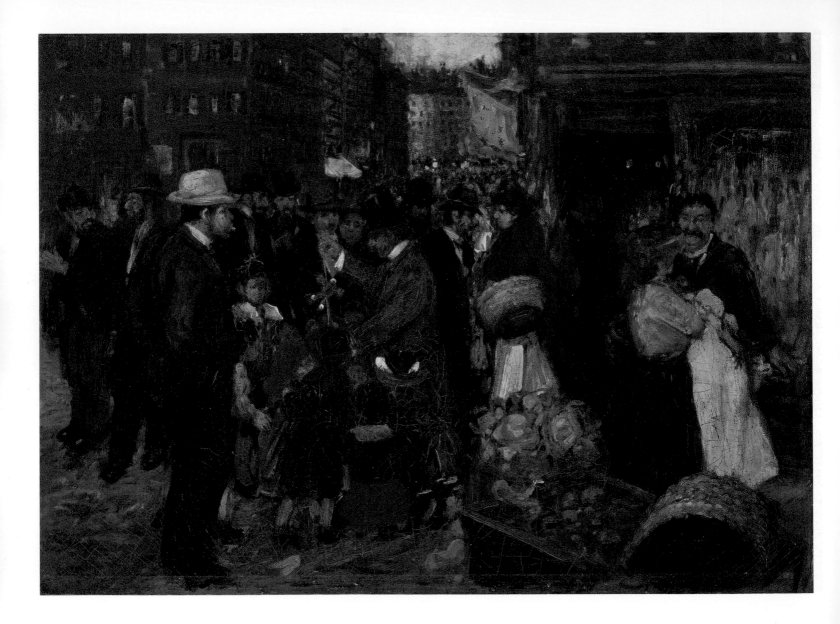

GEORGE LUKS, Street Scene (Hester Street), 1905

JOAQUIN TORRES-GARCIA, *New York Street Scene*, 1920

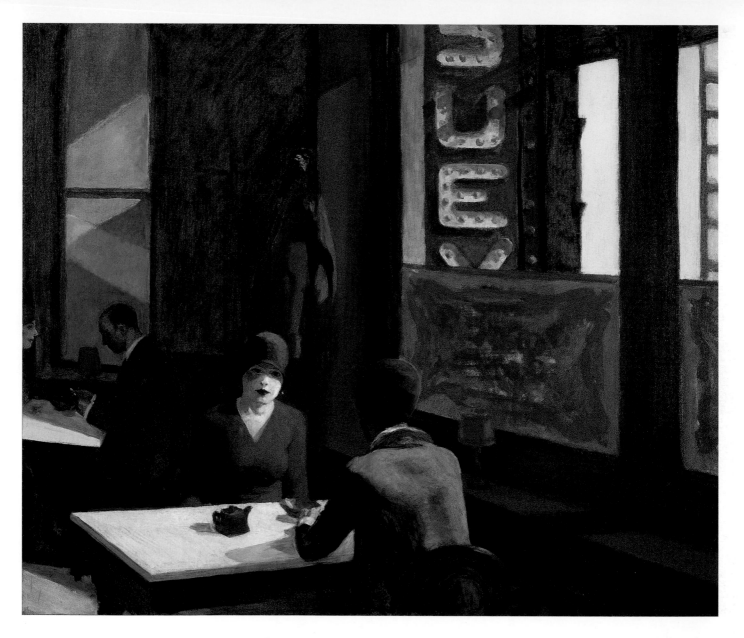

EDWARD HOPPER, Chop Suey, 1929

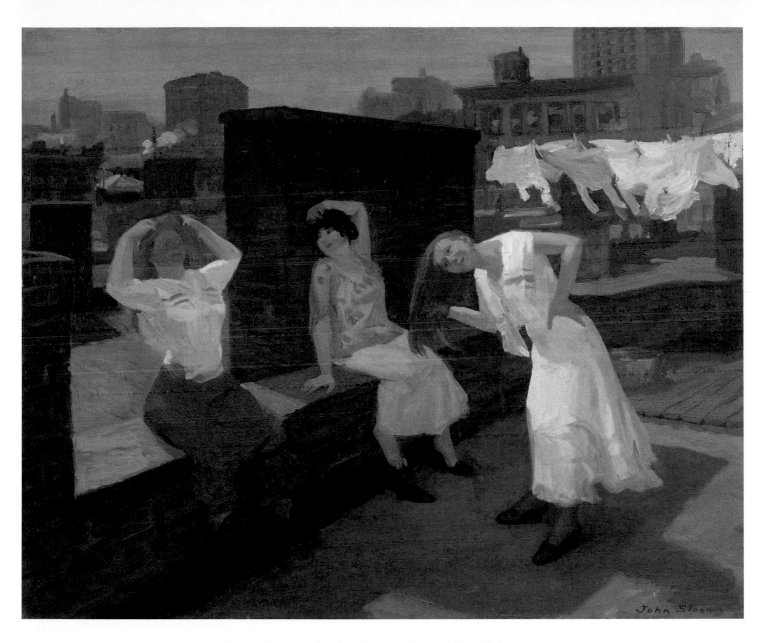

JOHN SLOAN, Sunday, Women Drying Their Hair, 1912

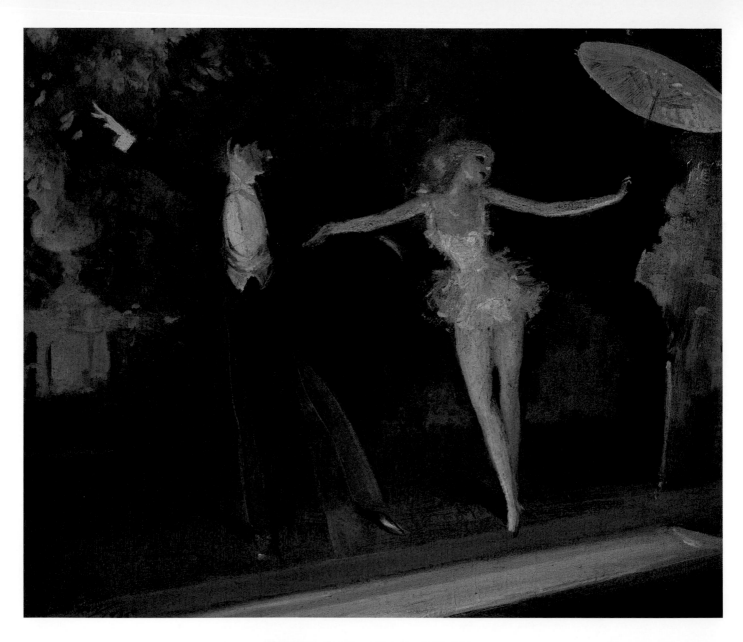

EVERETT SHINN, Curtain Call, 1925

GEORGE LUKS, The Amateurs, 1899

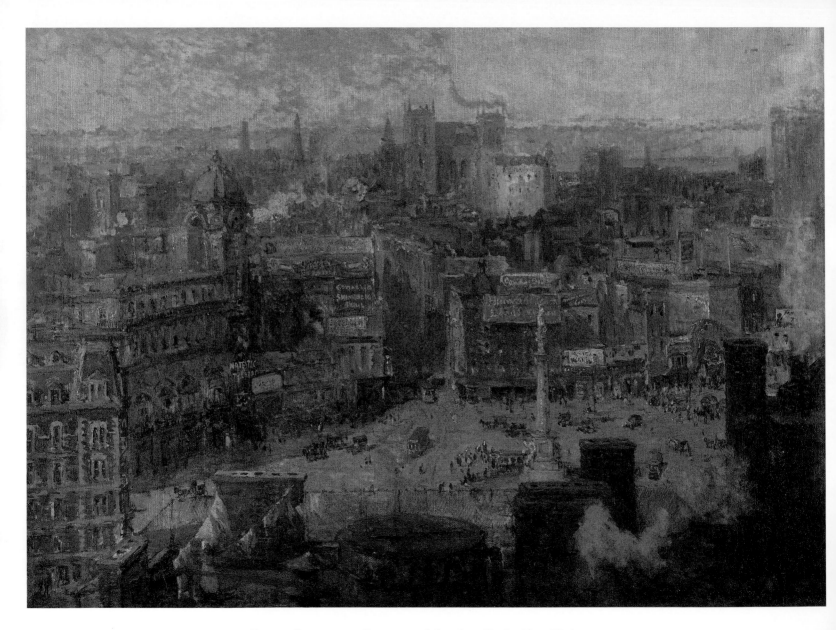

COLIN CAMPBELL COOPER, Columbus Circle, New York, 1909

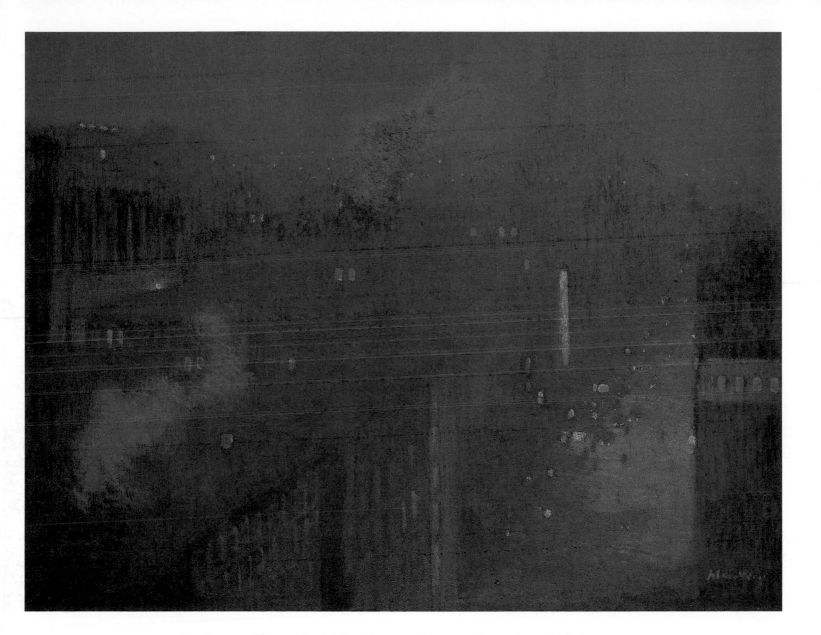

J. ALDEN WEIR, The Bridge: Nocturne (Nocturn: Queensboro Bridge), 1910

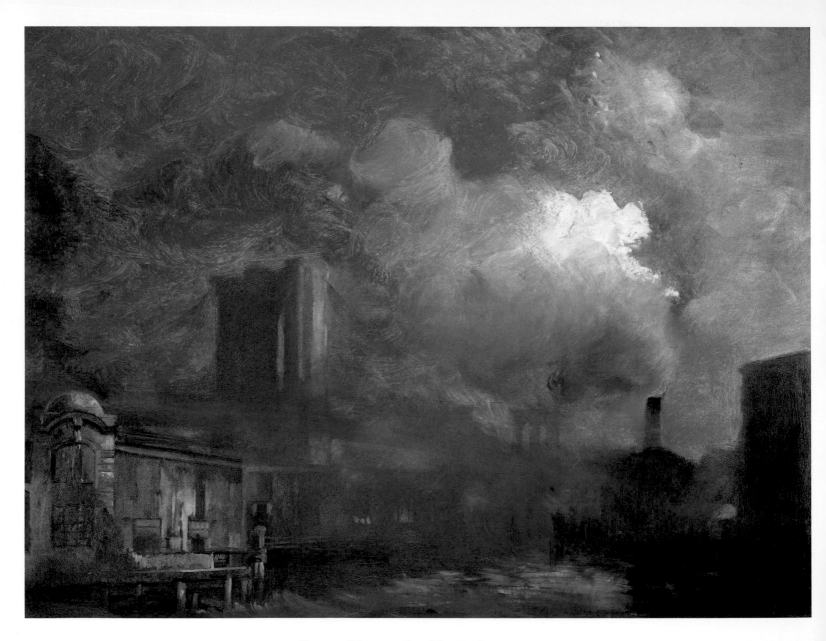

FRANK MASON, Brooklyn Bridge, 1950

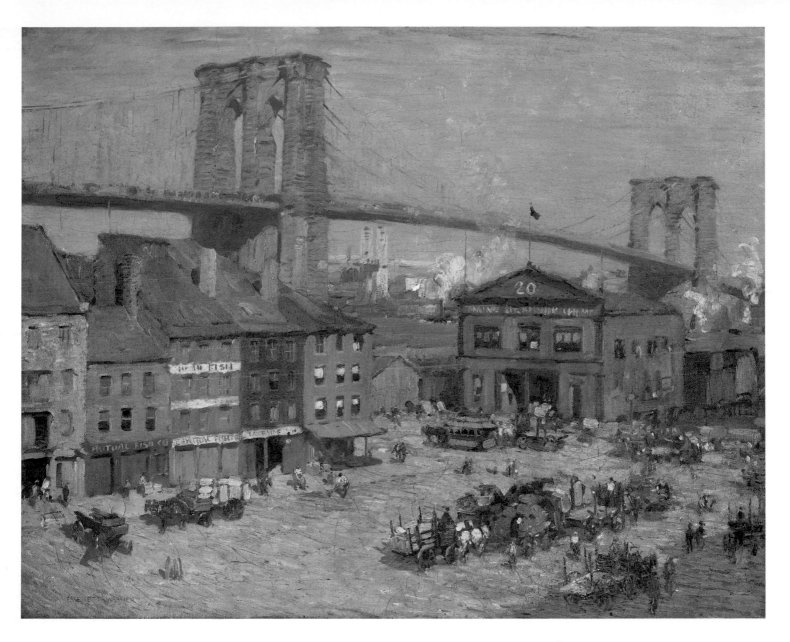

EVERETT LONGLEY WARNER, Along the River Front, New York, 1912

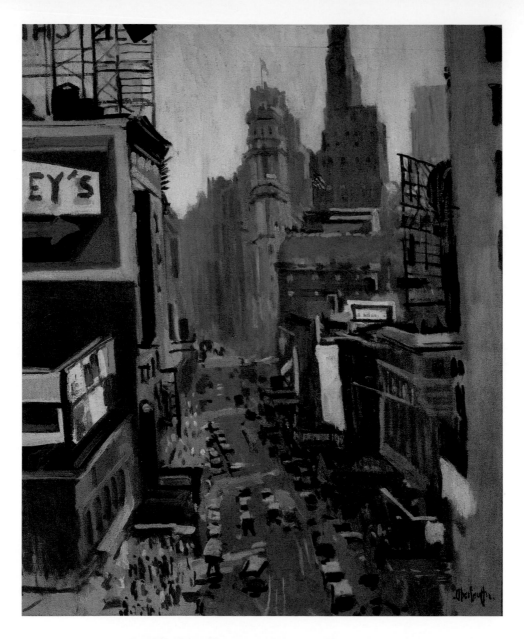

GEORGE OBERTEUFFER, Times Square, New York, c. 1925–30

WHEN ONE APPROACHES MANHATTAN ISLAND,
. . . the great towers . . . sometimes look like the fairy
stalagmites of an open grotto; and from an occasional
vantage point on the twentieth floor of an office building
one may now and again recapture this impression. . . .
In short, it is an architecture, not for men,
but for angels and aviators!

LEWIS MUMFORD, *Sticks and Stones, 1924*

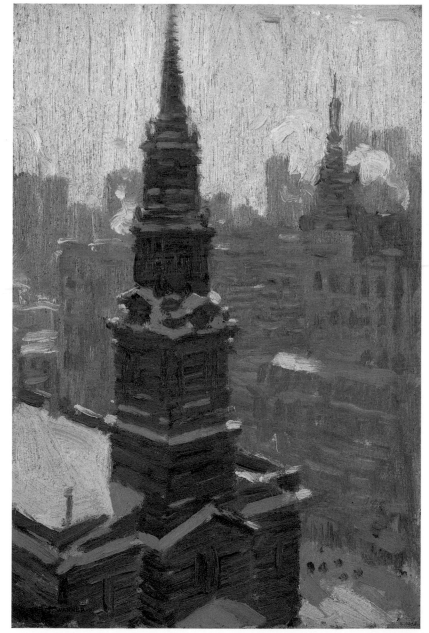

EVERETT LONGLEY WARNER, St. Paul's Chapel, c. 1915

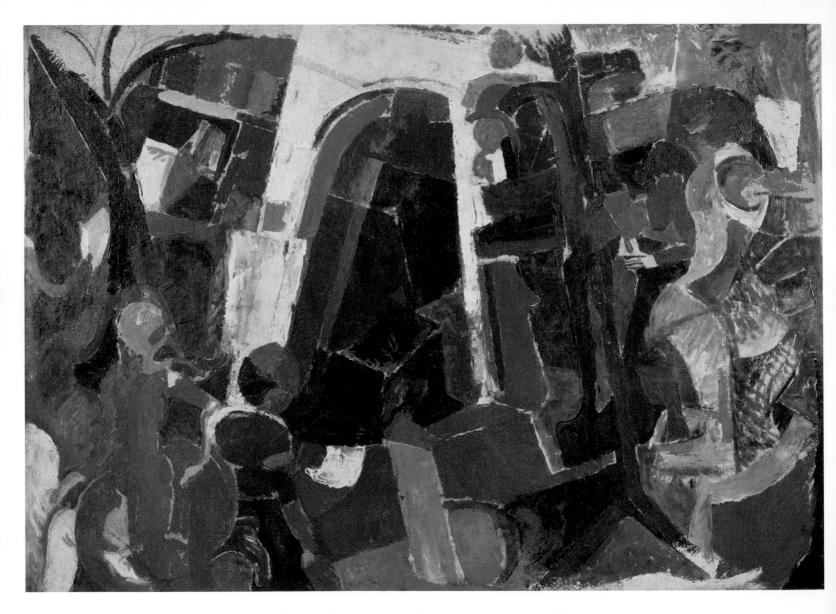

JAMES DAUGHERTY, Washington Square, c. 1919

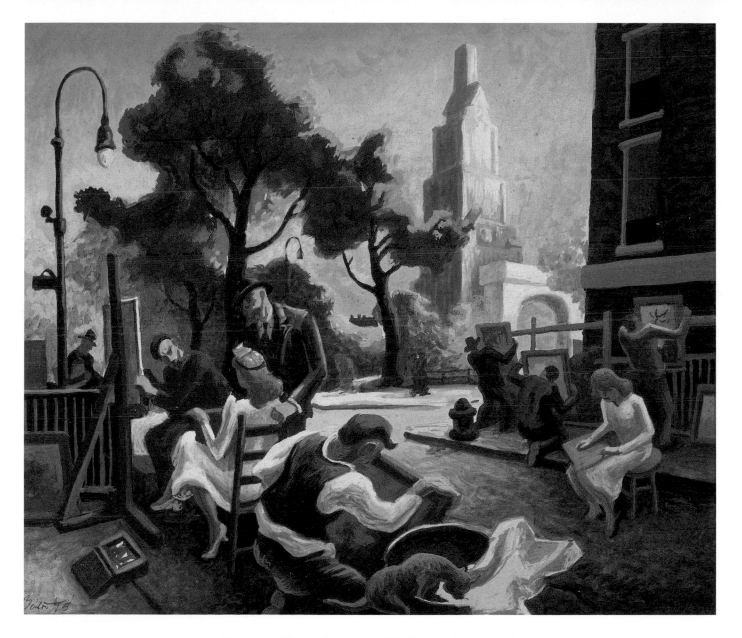

THOMAS HART BENTON, Washington Square, 1945

I SEE GREAT FORCES AT WORK; GREAT MOVEMENTS;
the large buildings and the small buildings; the warring of the great and the small;
influences of one mass on another greater or smaller mass. Feelings are aroused which give me the
desire to express the reaction of these "pull forces," those influences which play with one another;
great masses pulling smaller masses, each subject in some degree to the other's power. . . .

While these powers are at work pushing, pulling, sideways, downwards, upwards,
I can hear the sound of their strife and there is great music being played.

And so I try to express graphically what a great city is doing.
Within the frame there must be a balance, a controlling of these warring,
pushing, pulling forces. This is what I am trying to realize.

JOHN MARIN, *Camera Work*, 1913

JOHN MARIN, Woolworth Building, No. 28, 1912

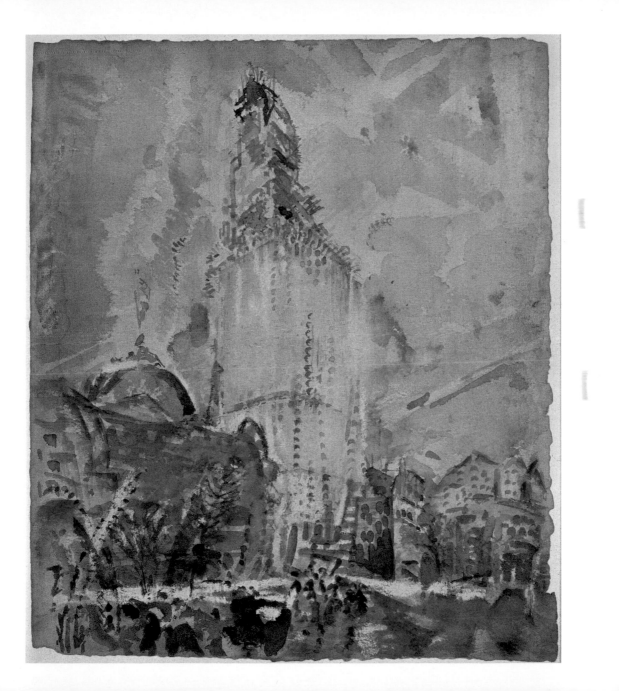

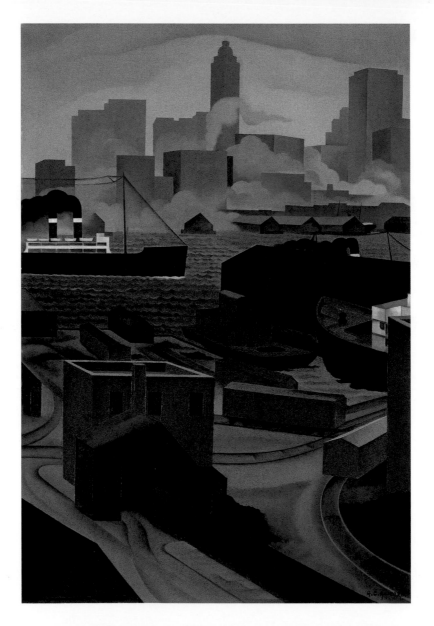

GEORGE COPELAND AULT, From Brooklyn Heights, 1925

FAR BELOW AND AROUND THE CITY LIKE A RAGGED PURPLE DREAM,
the wonderful, cruel, enchanting, bewildering, fatal, great city.

O. HENRY, *Strictly Business*, 1910

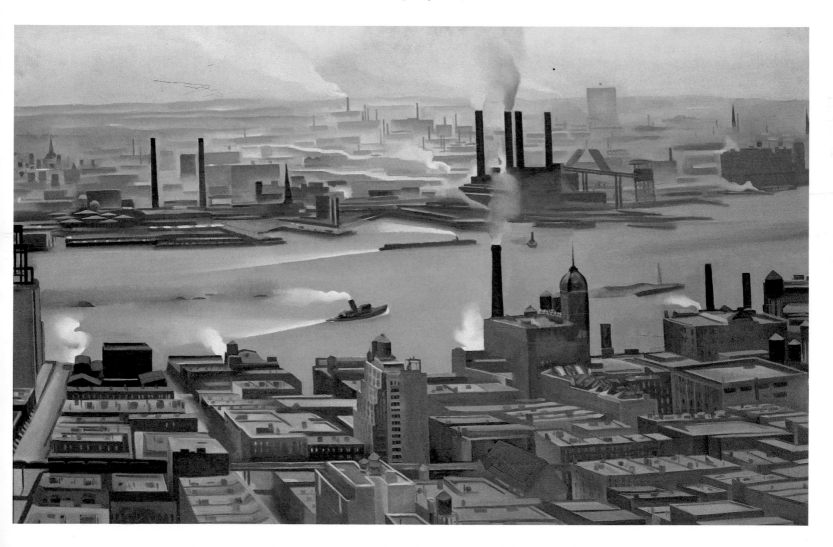

GEORGIA O'KEEFFE, East River from the 30th Story of the Shelton Hotel, 1928

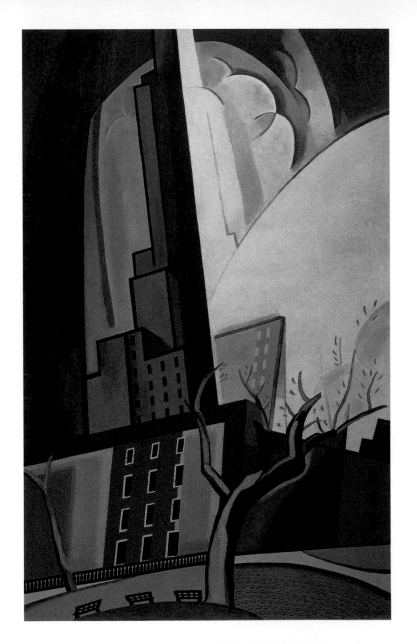

THAT ENFABLED ROCK,
that ship of life, that swarming million-footed,
tower-mastered, and sky-soaring citadel that hears the
magic name of Island of Manhattan.

THOMAS WOLFE, *The Web and the Rock*, 1939

OSCAR BLEUMNER, Circles of Washington Square, 1935

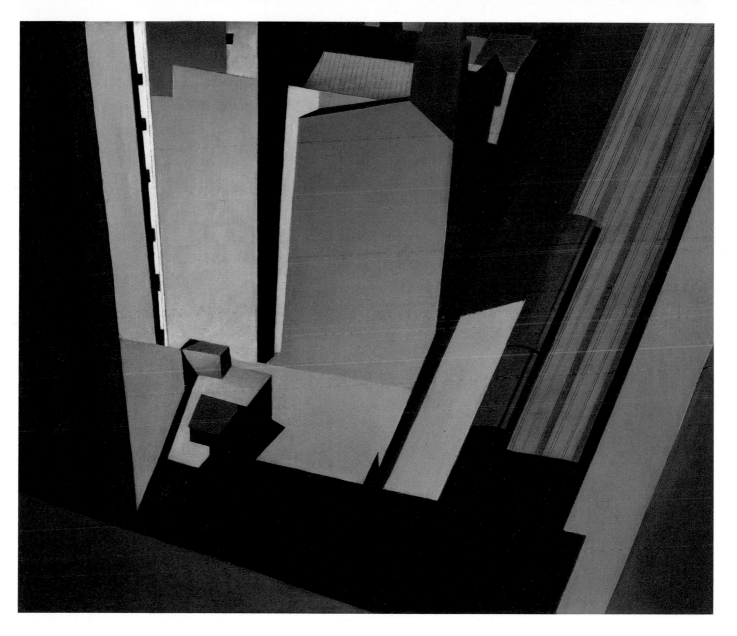

CHARLES SHEELER, Church Street El, 1920

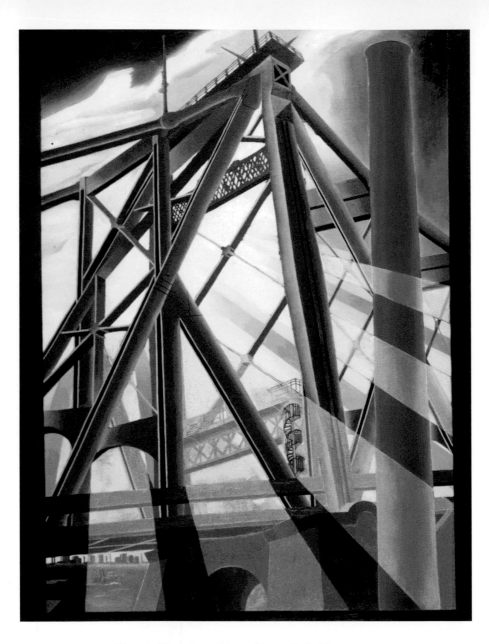

ELSIE DRIGGS, Queensborough Bridge, 1927

HERE I WAS IN NEW YORK,
city of prose and fantasy, of capitalistic automation, its
streets a triumph of cubism, its moral philosophy that of
the dollar. New York impressed me tremendously
because, more than any other city in the world, it is the
fullest expression of our modern age.

LEON TROTSKY, *My Life*, 1930

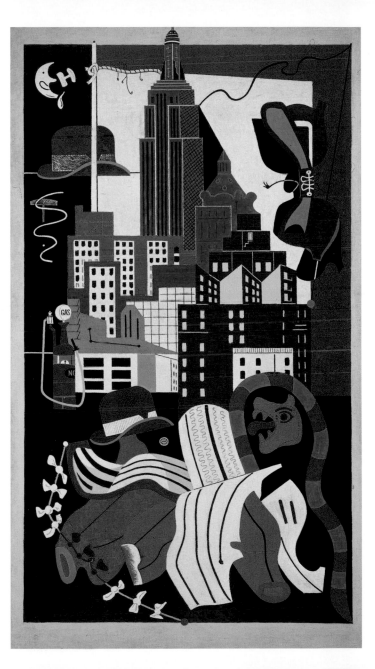

STUART DAVIS, New York Mural, 1932

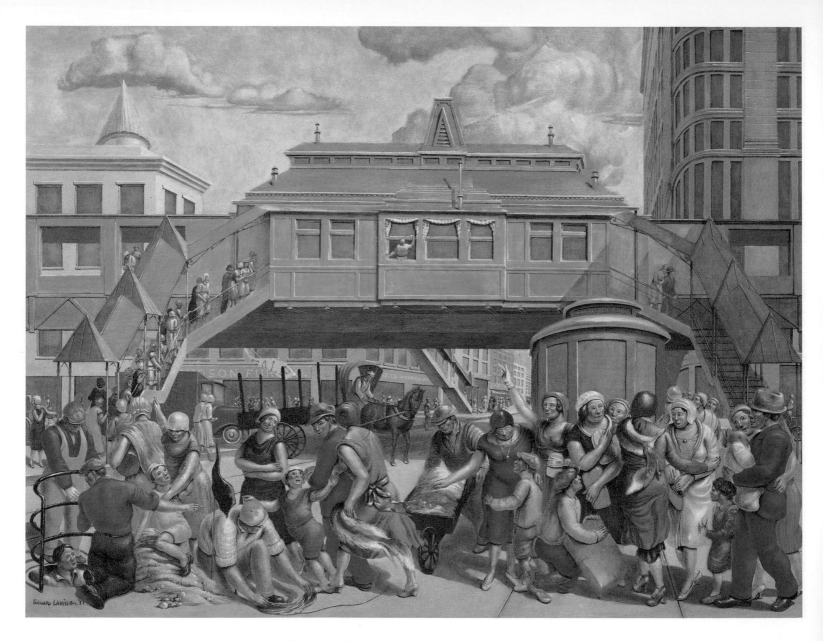

EDWARD LANING, Fourteenth Street, 1931

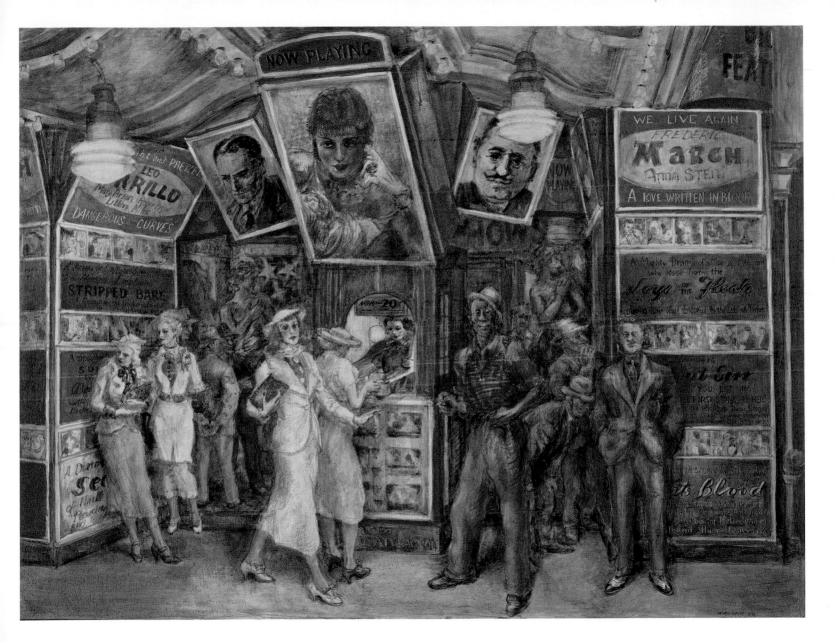

REGINALD MARSH, *Twenty Cent Movie*, 1936

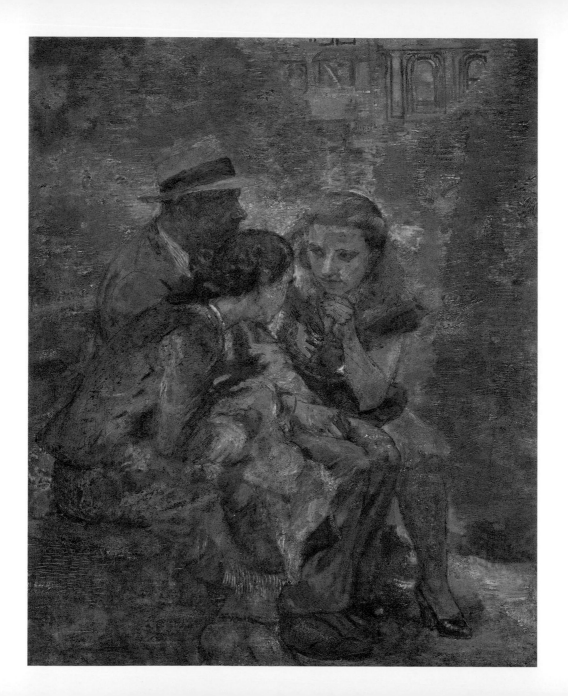

UNION SQUARE INTERESTS ME IN A WAY

that I don't understand myself. I think it has to do with a deep association from the time of my childhood, when my family lived one street from the "good" neighborhood in Detroit, and there was a kind of appetite that I developed for the other direction, toward the slum region. It seemed warmer to me. It seemed more human, and I liked it better. . . . I feel that may be part of the reason for loving the Union Square area, which is a rather shabby business region of New York. Yet young women that one sees here strike me as having a rather rich connotation. Of course, they're young—the ones that I'm thinking of are young—and they don't live in this region, as I know, because I've corralled some of them and got them into my studio. They generally live in the Bronx and work here. It's a moment in their lives when they are really in motion, because they, of course, are looking for husbands and, at the same time, they're earning their living.

ISABEL BISHOP, interview, Columbia University Oral History Project, 1957

ISABEL BISHOP, Double Date Delayed #1, 1948

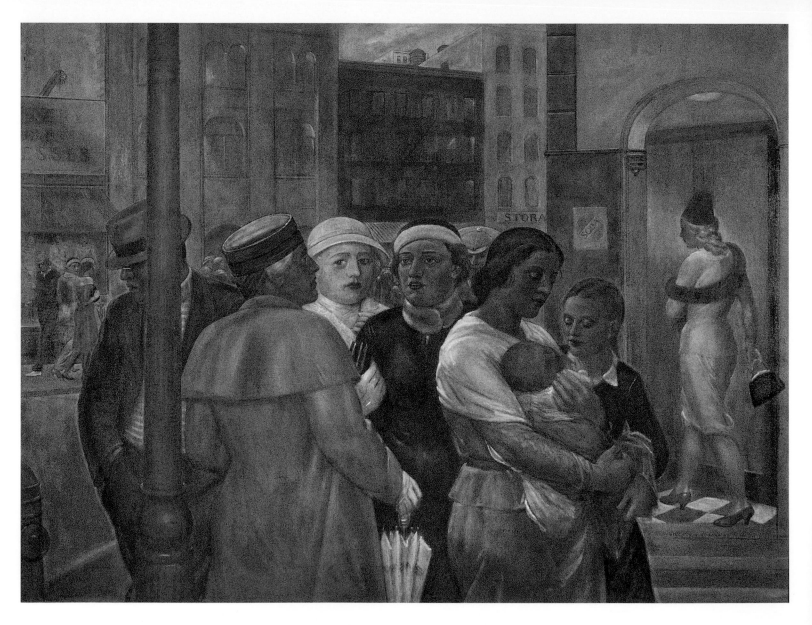

KENNETH HAYES MILLER, *City Street*, 1939

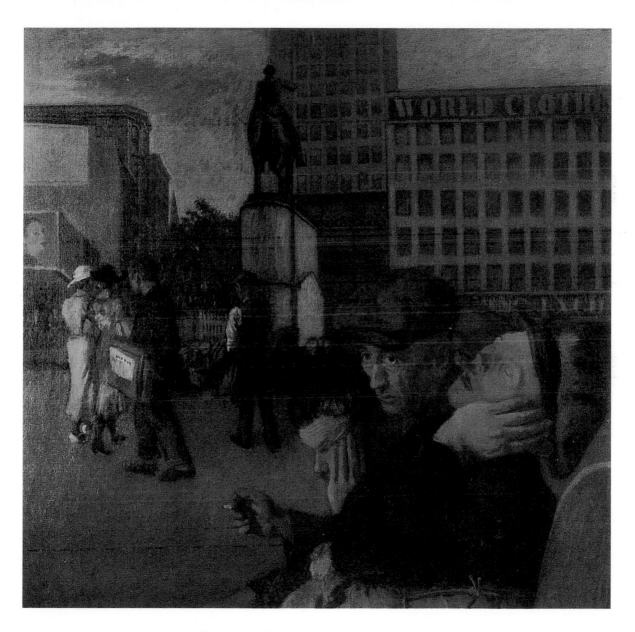

Raphael Soyer, In the City Park, 1934

THE FIRE BEGAN IN THE EIGHTH STORY.

The flames licked and shot their way up the other two stories. All three floors were occupied by the Triangle Shirtwaist Company. . . . The first signs that persons on the street knew that these three top stories had turned into red furnaces in which human creatures were being caught and incinerated was when screaming men and women and boys and girls crowded out on the many window ledges and threw themselves into the streets below.

NEW YORK WORLD, March 26, 1911

VICTOR JOSEPH GATTO, Triangle Fire, March 25, 1911, c. 1944

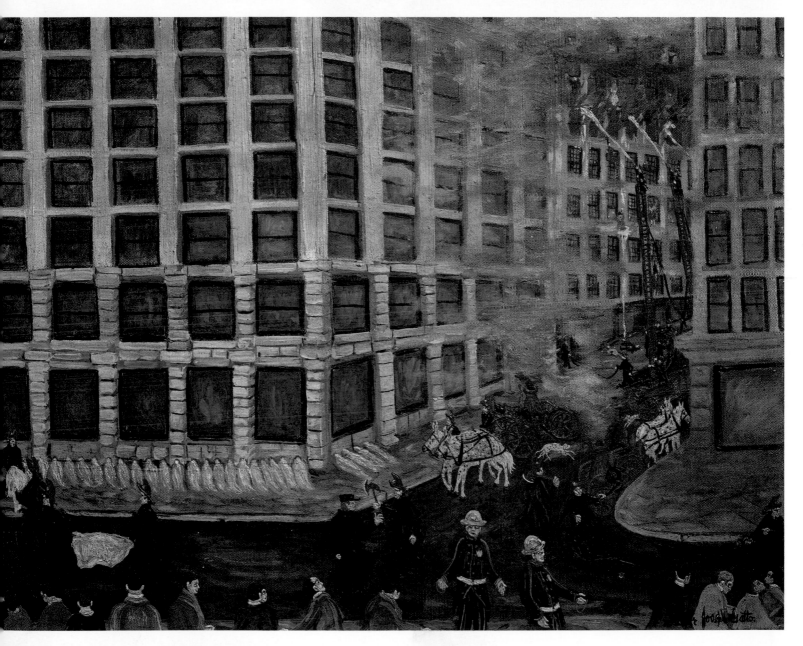

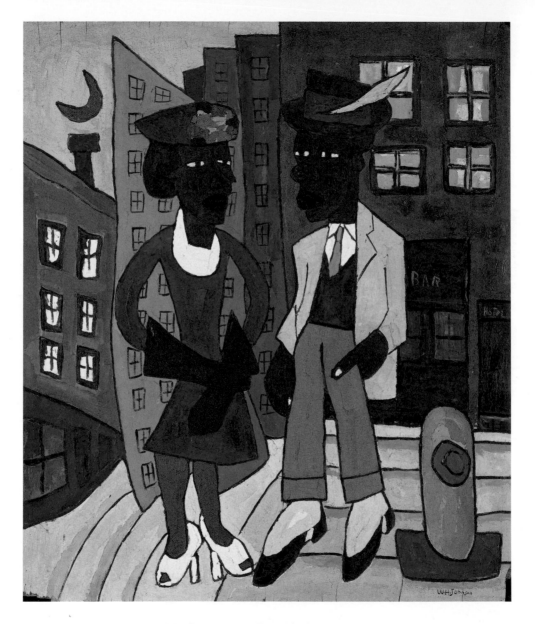

WILLIAM H. JOHNSON, Street Life, Harlem, c. 1939–40

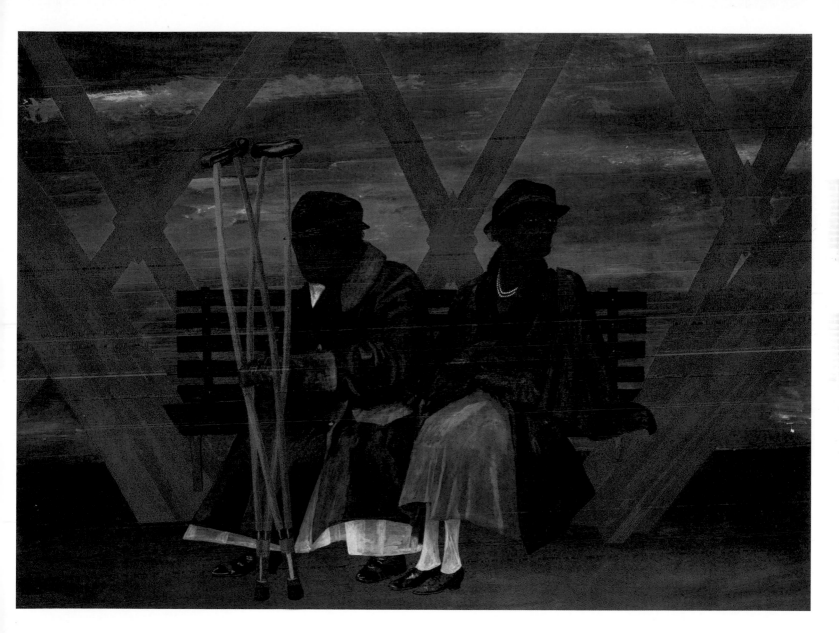

BEN SHAHN, *Willis Avenue Bridge*, 1940

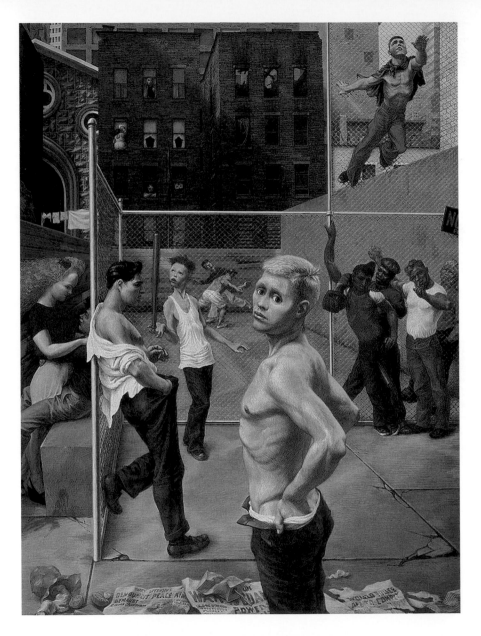

PAUL CADMUS, Playground, 1948

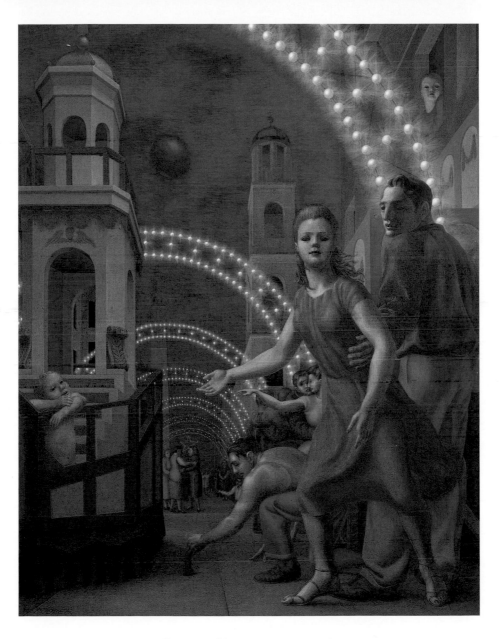

GEORGE TOOKER, *Festa*, 1948

William Merritt Chase
Lilliputian Boat Lake—Central Park, c. 1890
Oil on canvas, 16 x 24 in.
Private Collection
26

Colin Campbell Cooper
Columbus Circle, New York, 1909
Oil on canvas, 26 x 36 in.
Allentown Art Museum, Purchase: J.I. and
Anna Rodale Fund, 1945
94

Colin Campbell Cooper
Old Grand Central Station, 1906
Oil on canvas, 24^1/4 x 32 in.
Montclair Art Museum, Montclair, New Jersey
Gift of Mrs. Henry Lang, 1927.7
40

Francis Criss
Astor Place, 1932
Oil on canvas, 32 x 40 in.
Whitney Museum of American Art, New York
Purchase 33.9
54

Charles Curran
Flower Market, 1885
Oil on canvas, 14 x 22 in.
Private Collection
76

James Daugherty
Washington Square, c. 1919
Oil on canvas, 28 x 39^1/8 in.
Curtis Galleries, Minneapolis, Minnesota
100

Stuart Davis
New York Mural, 1932
Oil on canvas, 84 x 48 in.
Purchase, the R.H. Norton Trust, 64.17
Norton Museum of Art
West Palm Beach, Florida
Art © Estate of Stuart Davis/Licensed by VAGA,
New York, New York
109

E. Didier
Auction in Chatham Square, 1843
[depicting 1820]
Oil on canvas, 28^1/2 x 35^1/2 in.
Museum of the City of New York
Anonymous gift, 51.222.1
64

Elsie Driggs
Queensborough Bridge, 1927
Oil on canvas, 40^1/4 x 30^1/4 in.
Montclair Art Museum, Montclair, New Jersey
Museum purchase; Lang Acquisition
Fund, 1969.4
108

Asher B. Durand
*Dance on the Battery in the Presence of
Peter Stuyvesant*, 1838 [depicting 1809]
Oil on canvas, 32^1/4 x 46^5/8 in.
Museum of the City of New York
Gift of Jane Rutherford Faile through
Kenneth C. Faile, 55.248
11

Victor Joseph Gatto
Triangle Fire, March 25, 1911, c. 1944
Oil on canvas, 19 x 28 in.
Museum of the City of New York
Gift of Mrs. Henry L. Moses, 54.75
116–117

William Glackens
Central Park, in Winter, 1905
Oil on canvas, 25 x 30 in.
The Metropolitan Museum of Art
George A. Hearn Fund, 1921. (21.164)
Photograph © 1992 The Metropolitan Museum of Art
84

William Glackens
Park on the River, c. 1902
Oil on canvas, 25^7/8 x 32 in.
Brooklyn Museum
Dick S. Ramsay Fund 41.1085
81

Louis Guglielmi
View in Chambers Street, 1936
Oil on canvas, 30^1/4 x 24^1/4 in.
The Collection of the Newark Museum
Allocated by the WPA Federal
Art Project 1943, 43.192
55

Francis Guy
Tontine Coffee House, c. 1797 or c. 1803–1804
Oil on linen, 43 x 65 in.
Collection of The New-York Historical Society
1907.32
64–65

Jay Edward Hambidge
Music on the Mall, Central Park, by August 1901
Oil on canvas, 20 x 27^1/2 in.
Berry-Hill Galleries, New York
27

Childe Hassam
The Fourth of July, 1916
Oil on canvas, 36 x 26 in.
Private Collection
78

Childe Hassam
Horse Drawn Coach at Evening, New York, c. 1890
Watercolor and gouache on paper, 14 x 17^3/4 in.
Private Collection
19

Childe Hassam
A Spring Morning, c. 1890–91
Oil on canvas, 27^1/2 x 20 in.
Private Collection
18

Childe Hassam
*Sunset View of the New York Skyline from Brooklyn
(The Singer Building and Bankers' Trust
Building)*, 1911
Oil on canvas, 19^1/8 x 29^7/8 in.
Photograph courtesy of Spanierman
Gallery, LLC, New York
(title page)

E. Percel
Reception of General Louis Kossuth at
New York City, December 6, 1851, 1851
Oil on canvas, 44 x 63^1/$_2$ in.
Museum of the City of New York
Gift of Colonel Edgar William and
Mrs. Bernice Chrysler Garbisch, 66.2
69

Maurice Prendergast
Central Park, 1901
Watercolor on paper, 15^1/$_{16}$ x 22^1/$_8$ in.
Whitney Museum of American Art, New York
Purchase 32.42
83

Maurice Prendergast
The East River, 1901
Watercolor and pencil on paper
13^3/$_4$ x 19^3/$_4$ in.
Gift of Abby Aldrich Rockefeller (132.1935.a-b)
The Museum of Modern Art, New York
Digital Image © The Museum of Modern
Art/Licensed by SCALA/Art Resource, New York
80

Theodore Robinson
Fifth Avenue at Madison Square, 1894–95
Oil on canvas, 24^1/$_8$ x 19^1/$_8$ in.
Columbus Museum of Art, Ohio
Gift of Ferdinand Howald 1931.260
77

Hippolyte Sebron
Broadway at Spring Street, 1855
Oil on canvas, 20^1/$_4$ x 42^1/$_2$ in.
Private Collection
10

Ben Shahn
Willis Avenue Bridge, 1940
Tempera on paper, over composition board
23 x 31^3/$_8$ in.
Gift of Lincoln Kirstein (227.1947)
The Museum of Modern Art, New York
Art © Estate of Ben Shahn//Licensed by VAGA,
New York, New York
119

Charles Sheeler
Church Street El, 1920
Oil on canvas, 16 x 18^1/$_2$ in.
The Cleveland Museum of Art
Mr. and Mrs. William H. Marlatt Fund, 77.43
107

Everett Shinn
Curtain Call, 1925
Oil on canvas, 9^1/$_4$ x 11^1/$_4$ in.
Berry-Hill Galleries, New York
92

John Sloan
Dust Storm, Fifth Avenue, 1906
Oil on canvas, 22 x 27 in.
The Metropolitan Museum of Art
George A. Hearn Fund, 1921. (21.164)
Photograph © 1992 The Metropolitan Museum of Art
45

John Sloan
The Haymarket, Sixth Avenue, 1907
Oil on canvas, 26^1/$_8$ x 34^1/$_{16}$ in.
Brooklyn Museum
Gift of Mrs. Harry Payne Whitney 23.60
46

John Sloan
Sunday, Women Drying Their Hair, 1912
Oil on canvas, 26^1/$_8$ x 32^1/$_8$ in.
1938.67, museum purchase, Addison Gallery
of American Art, Phillips Academy, Andover,
Massachusetts. All Rights Reserved
Photograph: Greg Herns
91

Raphael Soyer
In the City Park, 1934
Oil on canvas, 37^1/$_4$ x 39^1/$_2$ in.
Private Collection
115

Joseph Stella
New York Interpreted: The Bridge (Brooklyn
Bridge), 1920–22
Oil on canvas, 88^1/$_2$ x 54 in.
The Collection of the Newark Museum
Purchase 1937 Felix Fuld Bequest Fund 37.288E
49

George Tooker
Festa, 1948
Egg tempera on gesso panel
21^1/$_2$ x 17^1/$_4$ in.
Collection of Leslee and David Rogath
121

George Tooker
The Subway, 1950
Egg tempera on composition board
18^1/$_8$ x 36^1/$_8$ in.
Whitney Museum of American Art, New York
Purchase, with funds from the Juliana Force
Purchase Award 50.23
57

Joaquin Torres-Garcia
New York Street Scene, 1920
Oil on paper mounted on cradled wood panel
18^3/$_8$ x 25^7/$_8$ in.
Hirshhorn Museum and Sculpture Garden
Smithsonian Institution, Gift of Joseph H.
Hirshhorn, 1972
89

Charles Frederic Ulrich
In the Land of Promise, Castle Garden, 1884
Oil on wood panel, 28^3/$_8$ x 35^3/$_4$ in.
Corcoran Gallery of Art, Washington, D.C.
Museum Purchase, Gallery Fund, 00.2
73

Caroline Van Hook Bean
Fifth Avenue at 48th St., 1918
Watercolor, gouache, and pencil on paper
17³/4 x 11³/4 in.
Collection of Remak Ramsay
79

Abraham Walkowitz
Central Park, 1907–09
Oil on canvas, 20 x 26 in.
Munson-Williams-Proctor Arts Institute
Museum of Art, Utica, New York, 91.27
85

Everett Longley Warner
Along the River Front, New York, 1912
Oil on canvas, 32 x 40 in.
Toledo Museum of Art
Museum Purchase Fund, 1914.109
97

Everett Longley Warner
St. Paul's Chapel, c. 1915
Oil on canvasboard, 9³/8 x 6¹/4 in.
Collection of Remak Ramsay
99

Samuel B. Waugh
The Bay and Harbor of New York, c. 1853–55
Watercolor on canvas, 99¹/5 x 198¹/4 in.
Museum of the City of New York
Gift of Mrs. Robert L. Littlejohn, 33.169.1
60–61

Max Weber
Rush Hour, New York, 1915
Oil on canvas, 44 x 37³/4 in.
National Gallery of Art, Washington
Gift of the Avalon Foundation.
Image © 2005 Board of Trustees, National Gallery
of Art, Washington
42

J. Alden Weir
*The Bridge: Nocturne (Nocturn: Queensboro
Bridge)*, 1910
Oil on canvas mounted on wood
29 x 39¹/2 in.
Hirshhorn Museum and Sculpture Garden,
Smithsonian Institution, Gift of Joseph H.
Hirshhorn, 1966
95

Thomas Kelah Wharton
New York from Brooklyn Heights, 1834
Oil on canvas, 22¹/4 x 30¹/4 in.
Berry-Hill Galleries, New York
7

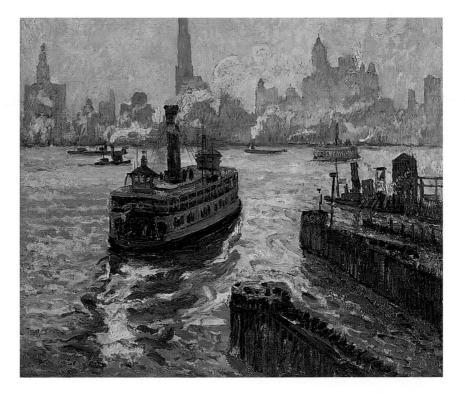

RICHARD HALEY LEVER, New York Skyline from the Lackawanna Ferry Depot, 1928

127

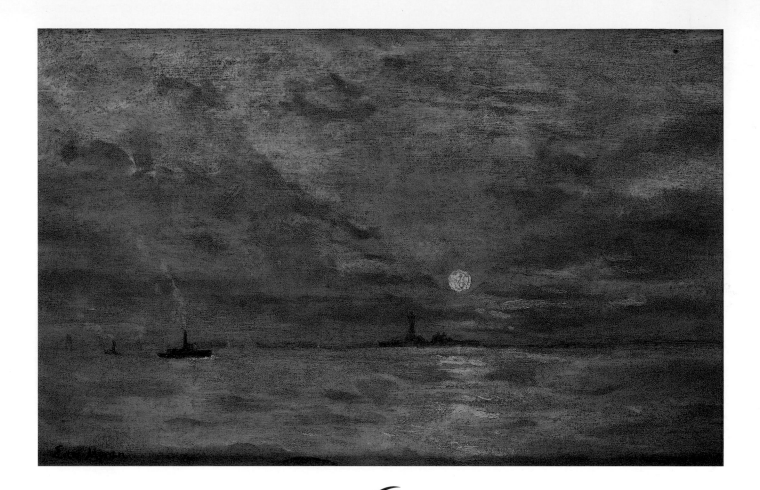

RETURNED TO NEW YORK LAST NIGHT.

Out today on the waters for a sail in the wide bay. . . . From my point of view, as I write amid the soft breeze, . . . surely
nothing on earth of its kind can go beyond this show. . . . And rising out of the mist, tall-topped, ship-hemmed, modern,
American, yet strangely oriental, V-Shaped Manhattan, with its compact mass, its spires, its cloud-touching edifices
grouped at the center . . . delicious light of heaven above, and June haze on the surface below.

WALT WHITMAN, *Specimen Days*, 1882

EDWARD P. MORAN, New York Harbor, n.d.